Masterpieces of Andrea del Sarto (1908)

ISBN-13 : 978-1512324464
ISBN-10 : 1512324469
Copyright©2012-2014 Iacob Adrian
All Rights Reserved.

Notice

This documentary study use historic, archived documents.

Because of this, some pages may look blurry or low quality.

Still are included in this book because they have

high value from critical, documentary, historical,

informative and journalistic point of view .

Dtp and visual art

Iacob Adrian

THE
MASTERPIECES
OF
ANDREA
DEL SARTO

Sixty reproductions of photographs from the original paintings, affording examples of the different characteristics of the Artist's work

Author statement

This is a series of art books.

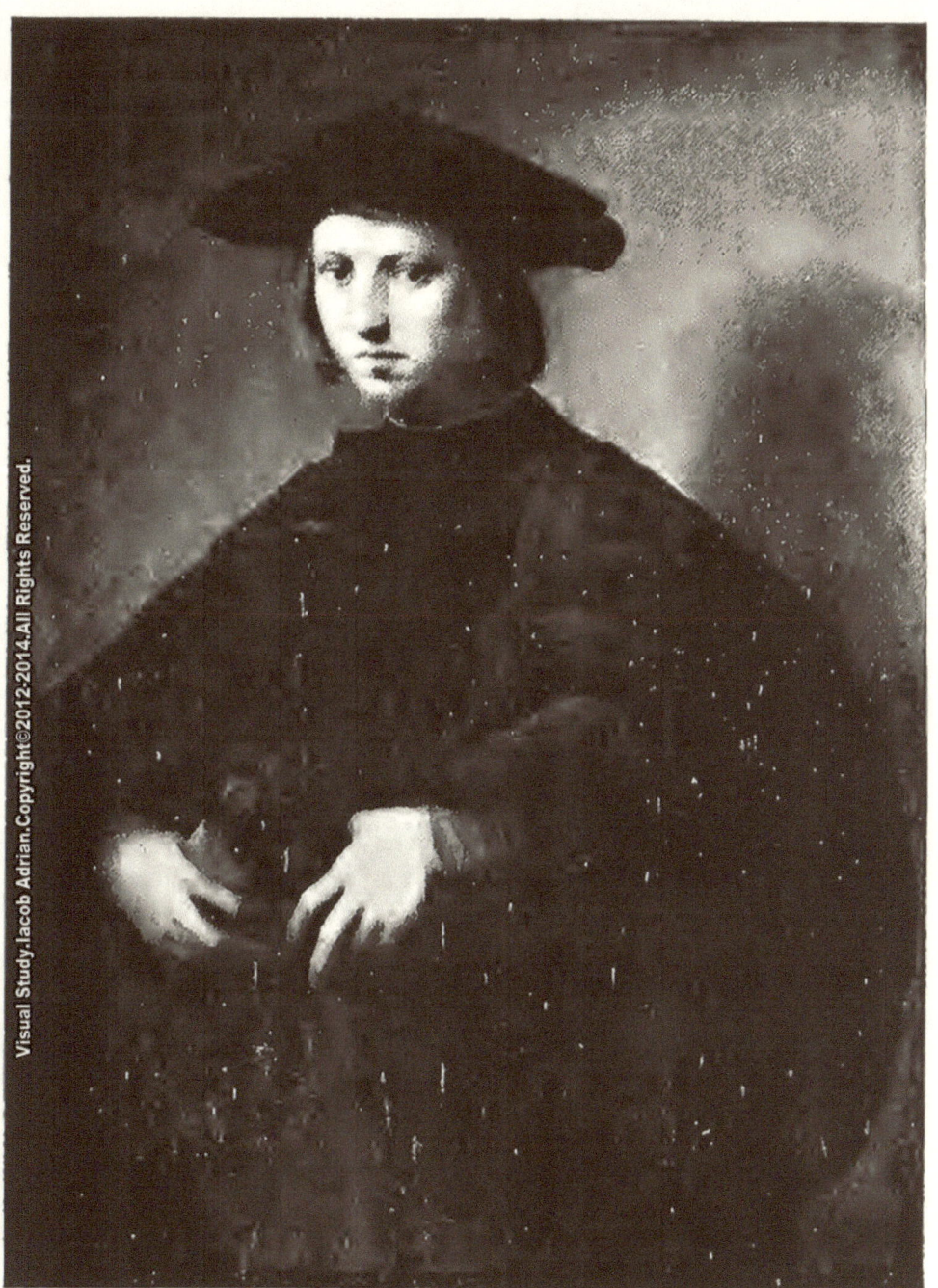

PORTRAIT OF HIMSELF
(Pitti, Florence)

PORTRAIT DE L'ARTISTE
(Galerie Pitti, Florence)

SELBSTBILDNIS
(Florenz, Galerie Pitti)
D. Anderson, Photo.

This little Book conveys the greetings of

..

to

..

―――――――――――――

PORTRAIT OF HIMSELF　　　　　PORTRAIT DE L'ARTISTE
(*Pitti, Florence*)　　　　　(*Galerie Pitti, Florence*)
SELBSTBILDNIS
(*Florenz, Galerie Pitti*)
G. Brogi, Photo.

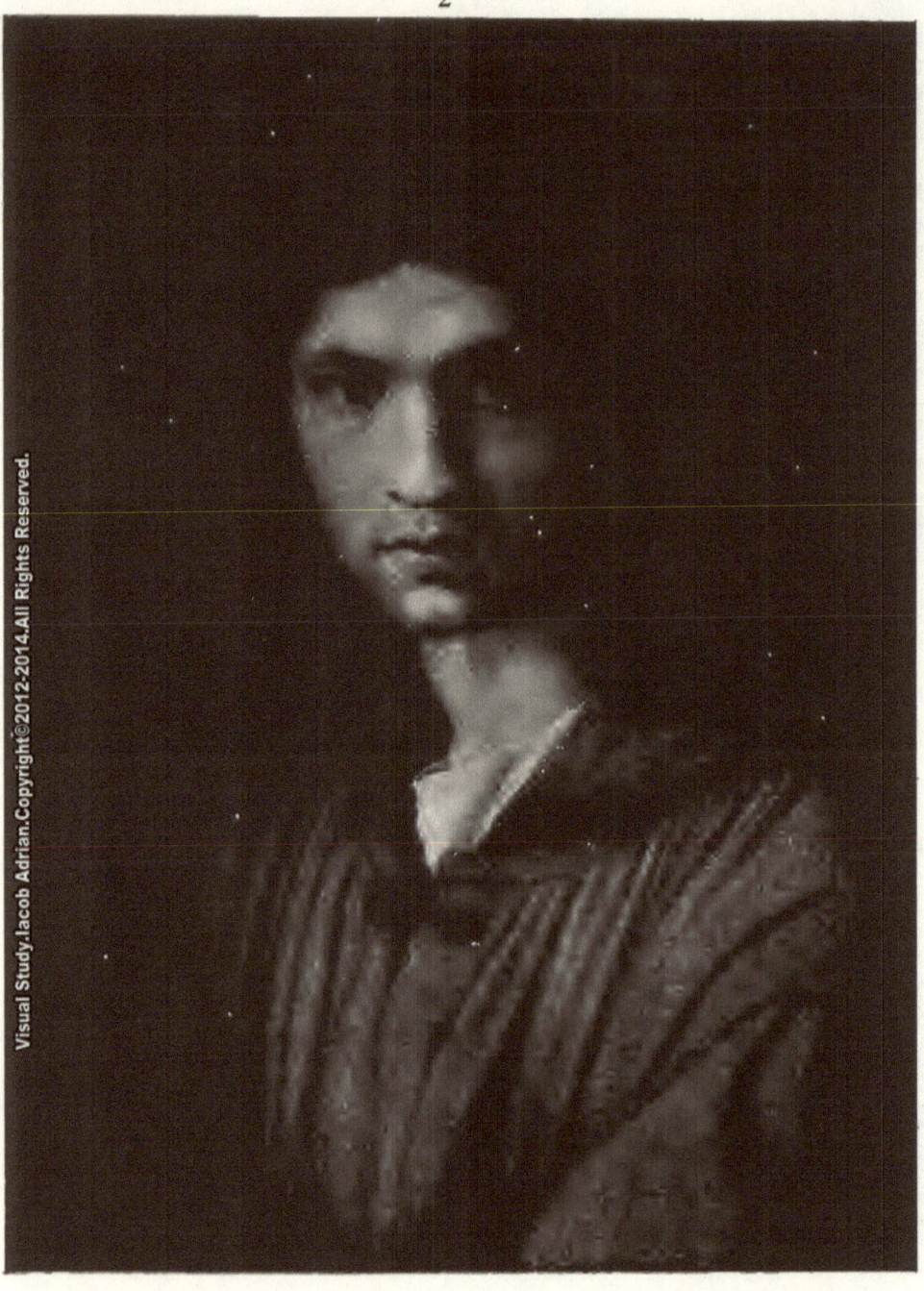

PORTRAIT OF HIMSELF　　　　PORTRAIT DE L'ARTISTE
(*Uffizi, Florence*)　　　　(*Galerie des Offices, Florence*)
SELBSTBILDNIS
(*Florenz, Uffizien*)
F. Hanfstaengl, Photo.

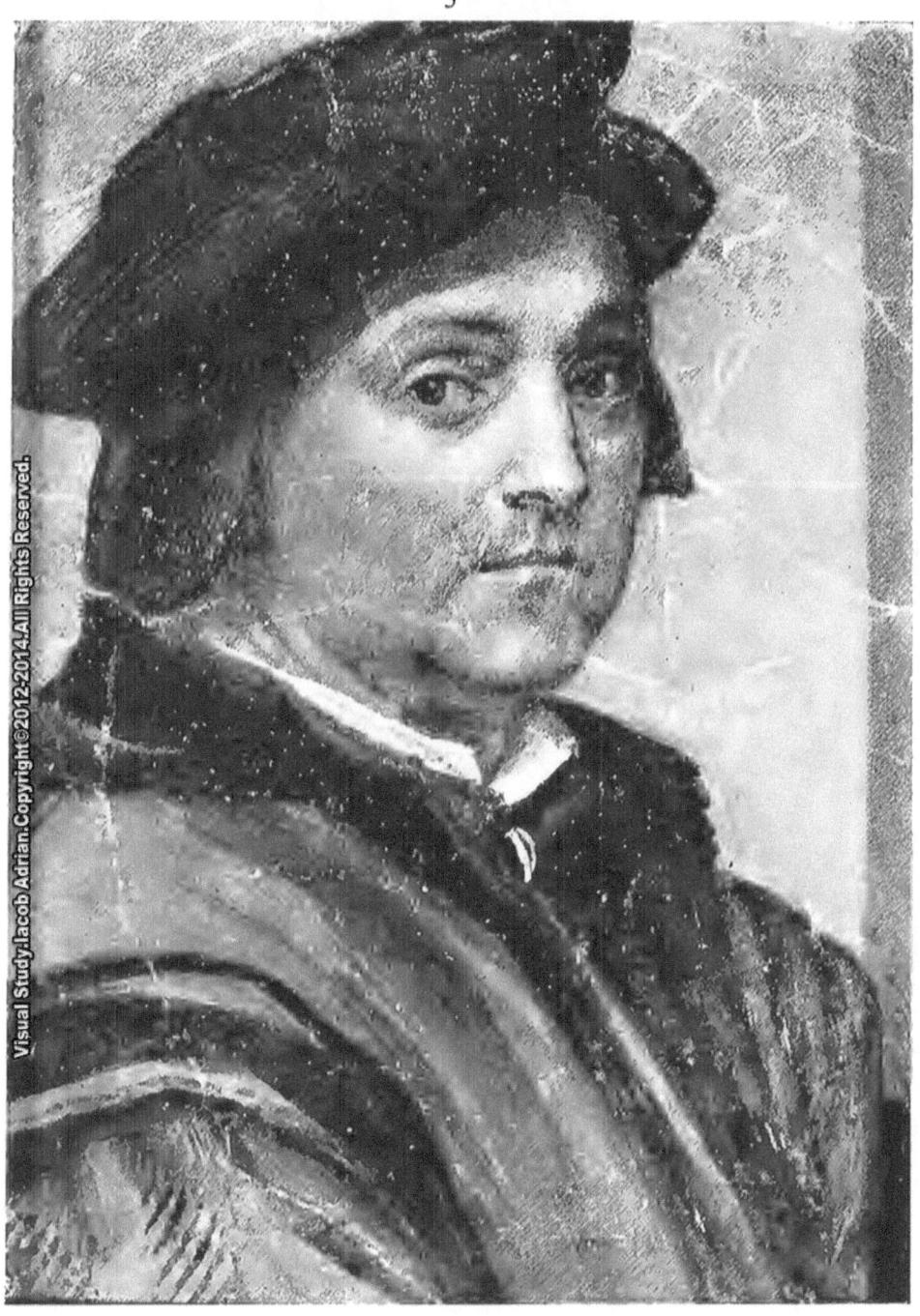

PORTRAIT OF HIMSELF
(FRESCO)
(*Uffizi, Florence*)

PORTRAIT DE L'ARTISTE
(FRESQUE)
(*Galerie des Offices, Florence*)

SELBSTBILDNIS (FRESKE)
(*Florenz, Uffizien*)

D. *Anderson, Photo.*

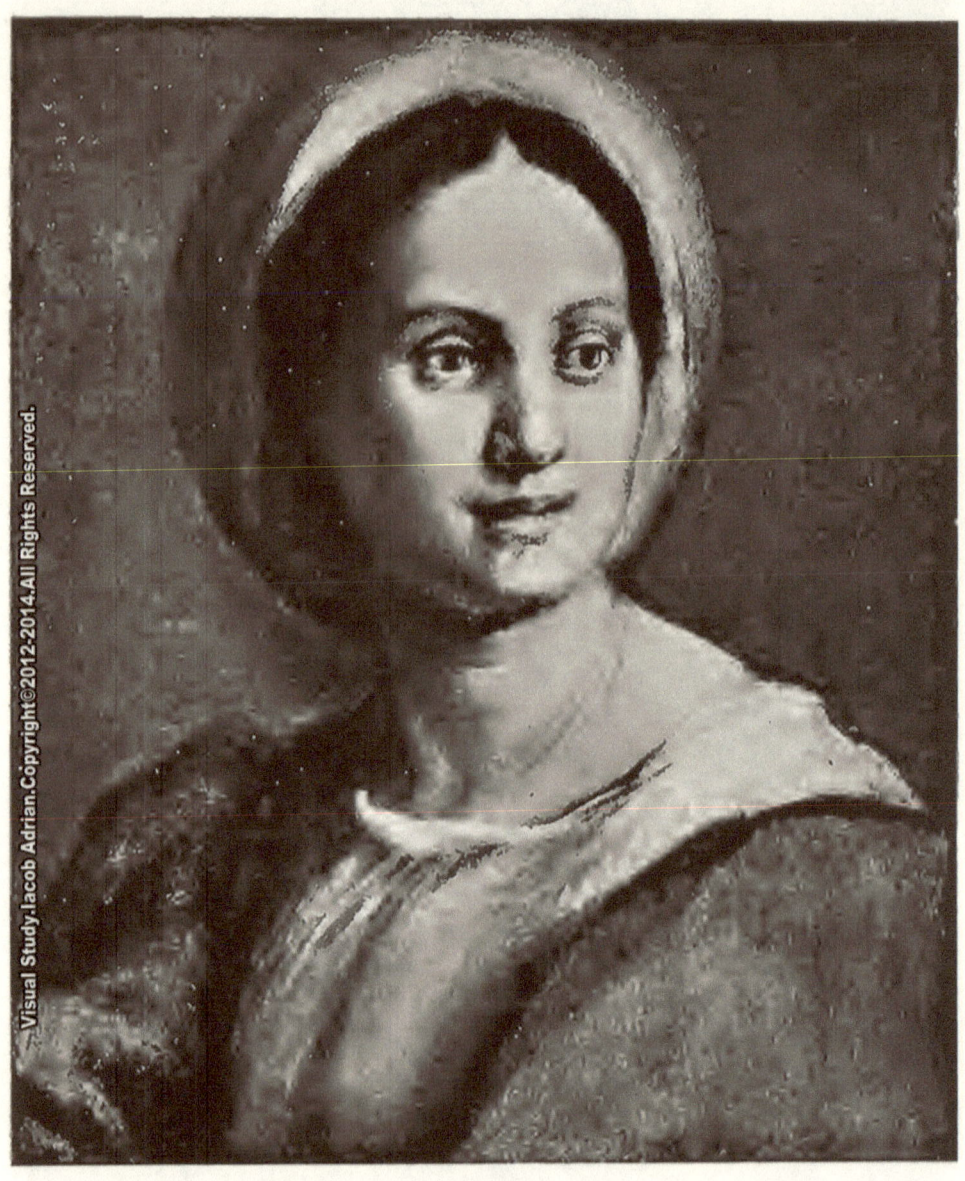

LUCRETIA DEL FEDE
(DEL. SARTO'S WIFE)
(*Royal Gallery, Berlin*)

LUCRÈCE DEL FEDE
(FEMME DE DEL SARTO)
(*Musée royal, Berlin*)

LUKRETIA DEL FEDE (DEL. SARTOS FRAU)
(*Berlin, Kgl. Galerie*)
F. Hanfstaengl, Photo.

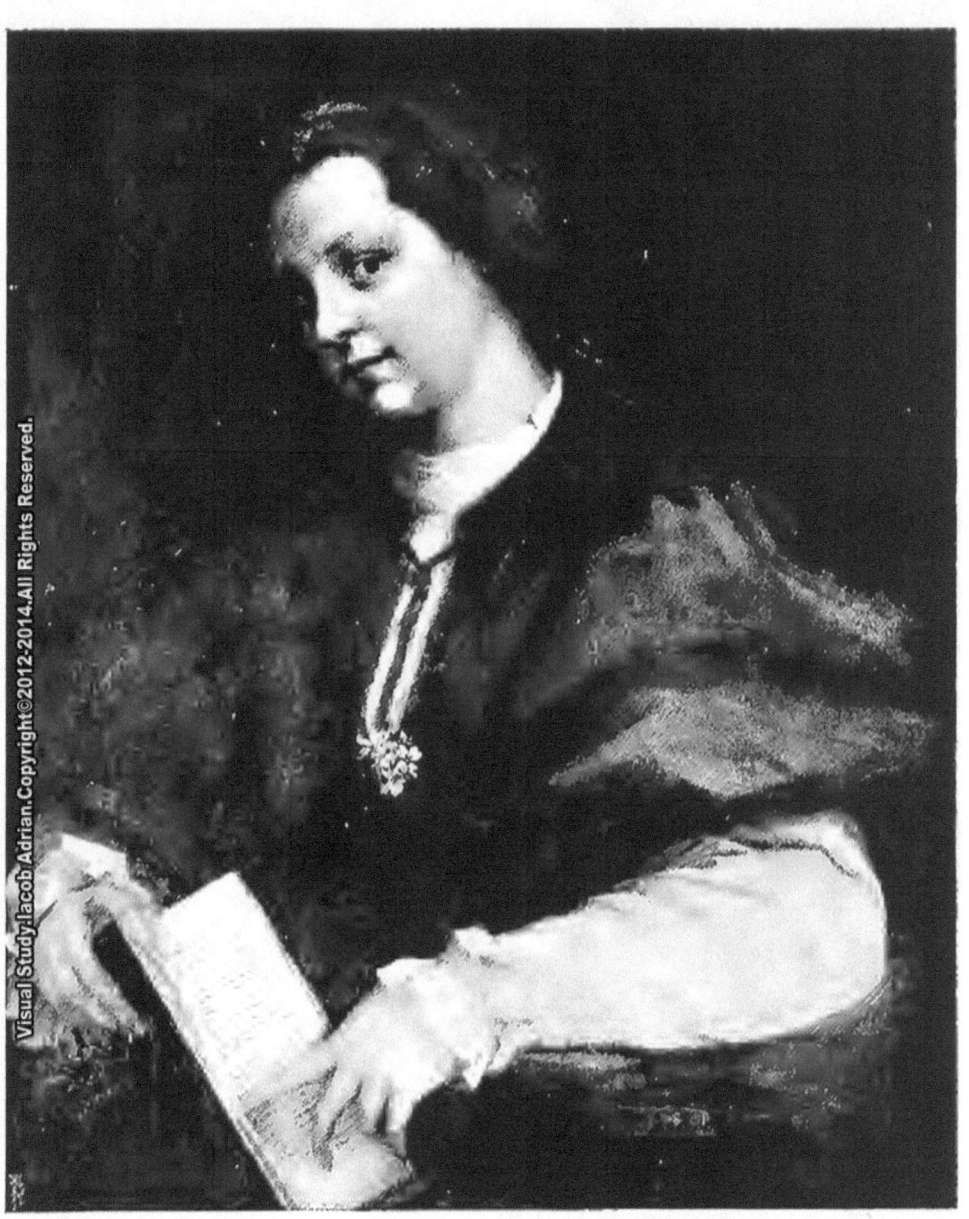

LUCRETIA DEL FEDE
(*Uffizi, Florence*)

LUCRÈCE DEL FEDE
(*Galerie des Offices, Florence*)

LUKRETIA DEL FEDE
(*Florenz, Uffizien*)
Frat. Alinari, Photo.

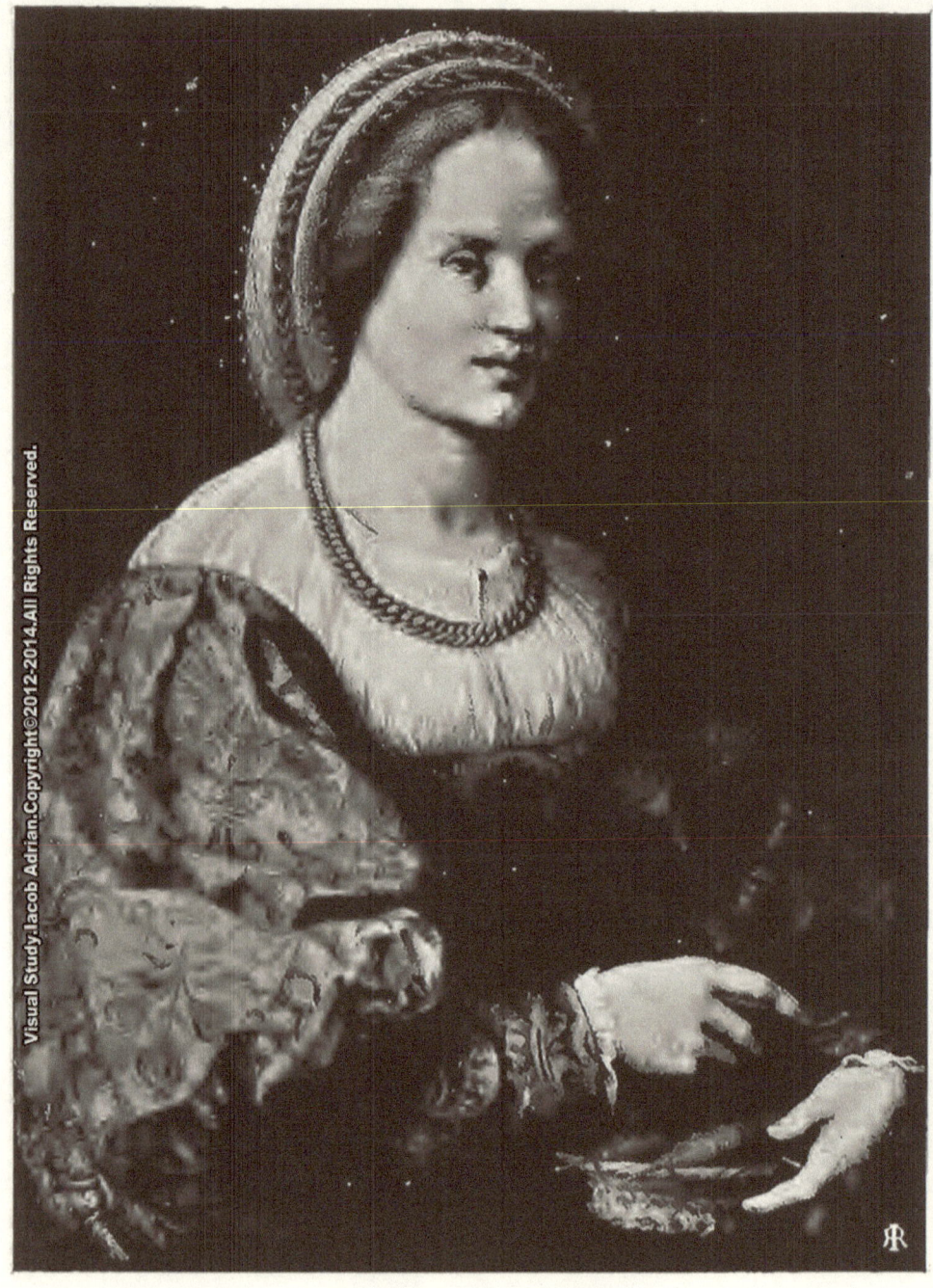

PORTRAIT OF A LADY
(*Uffizi, Florence*)

PORTRAIT DE DAME
(*Galerie des Offices, Florence*)

BILDNIS EINER FRAU
(*Florenz, Uffizien*)
G. *Brogi, Photo.*

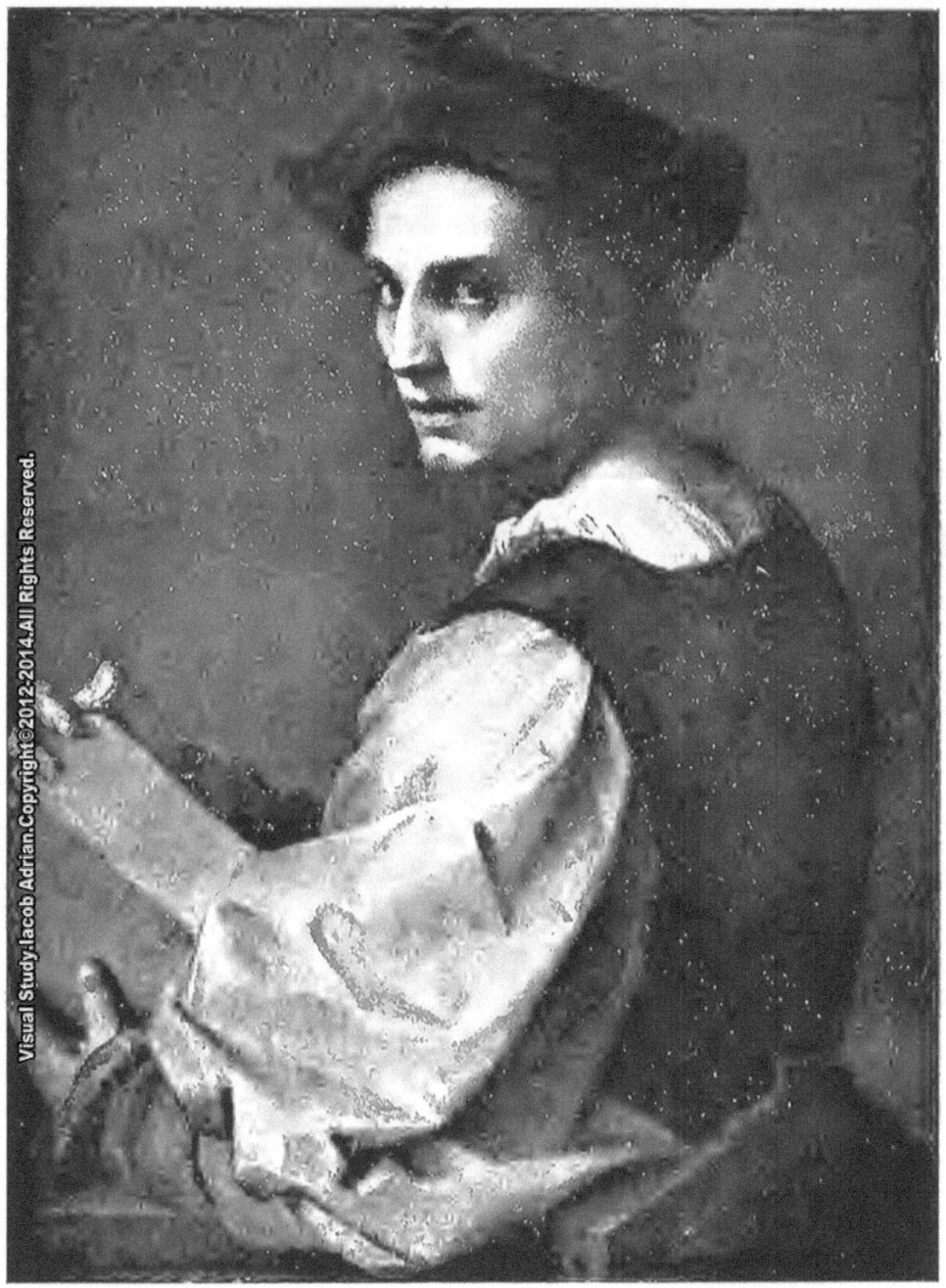

PORTRAIT OF A SCULPTOR
(*National Gallery, London*)

PORTRAIT D'UN SCULPTEUR
(*Galerie nationale, Londres*)

BILDNIS EINES BILDHAUERS
(*London, Nationalgalerie*)

F. Hanfstaengl, Photo.

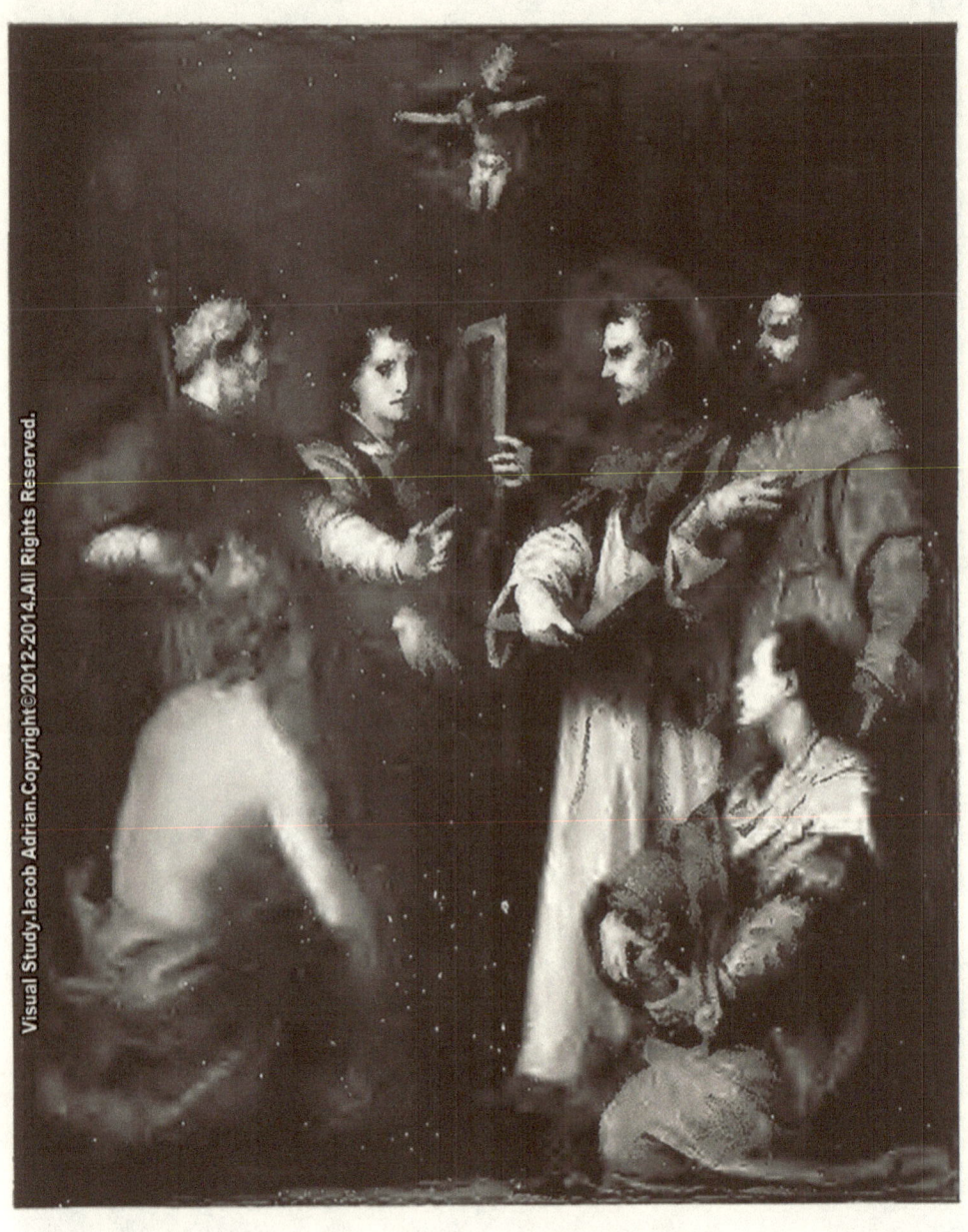

THE DISPUTE ON THE TRINITY LA DISPUTE SUR LA TRINITÉ
(*Uffizi, Florence*) (*Galerie des Offices, Florence*)
DISPUT ÜBER DIE HL. DREIEINIGKEIT
(*Florenz, Uffizien*)
F Hanfstaengl, Photo

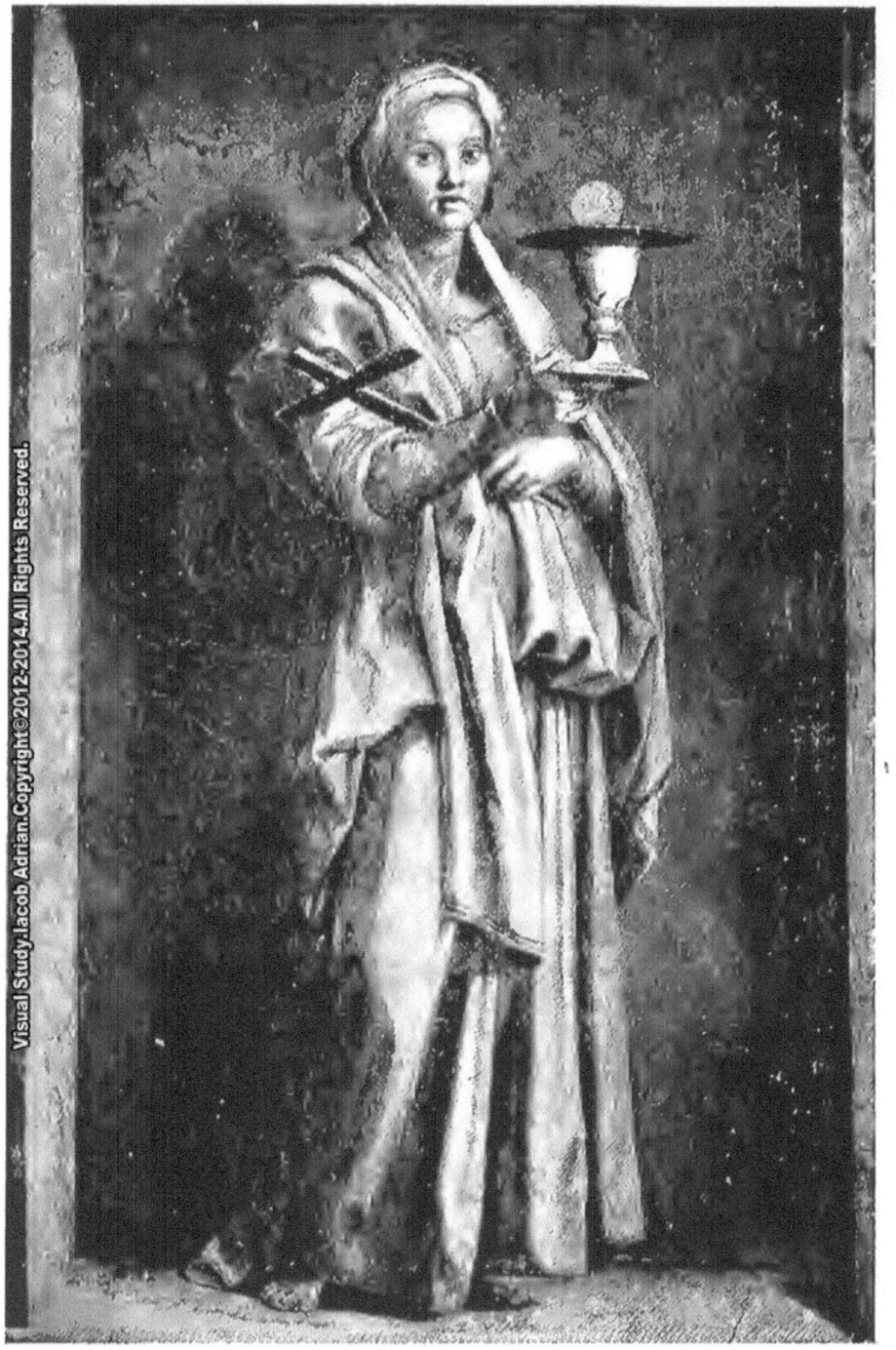

FAITH (FRESCO)
(*Scalzo, Florence*)

LA FOI (FRESQUE)
(*Scalzo, Florence*)

DIE GLAUBE (FRESKE)
(*Florenz, Scalzo*)

Frat. Alinari, Photo.

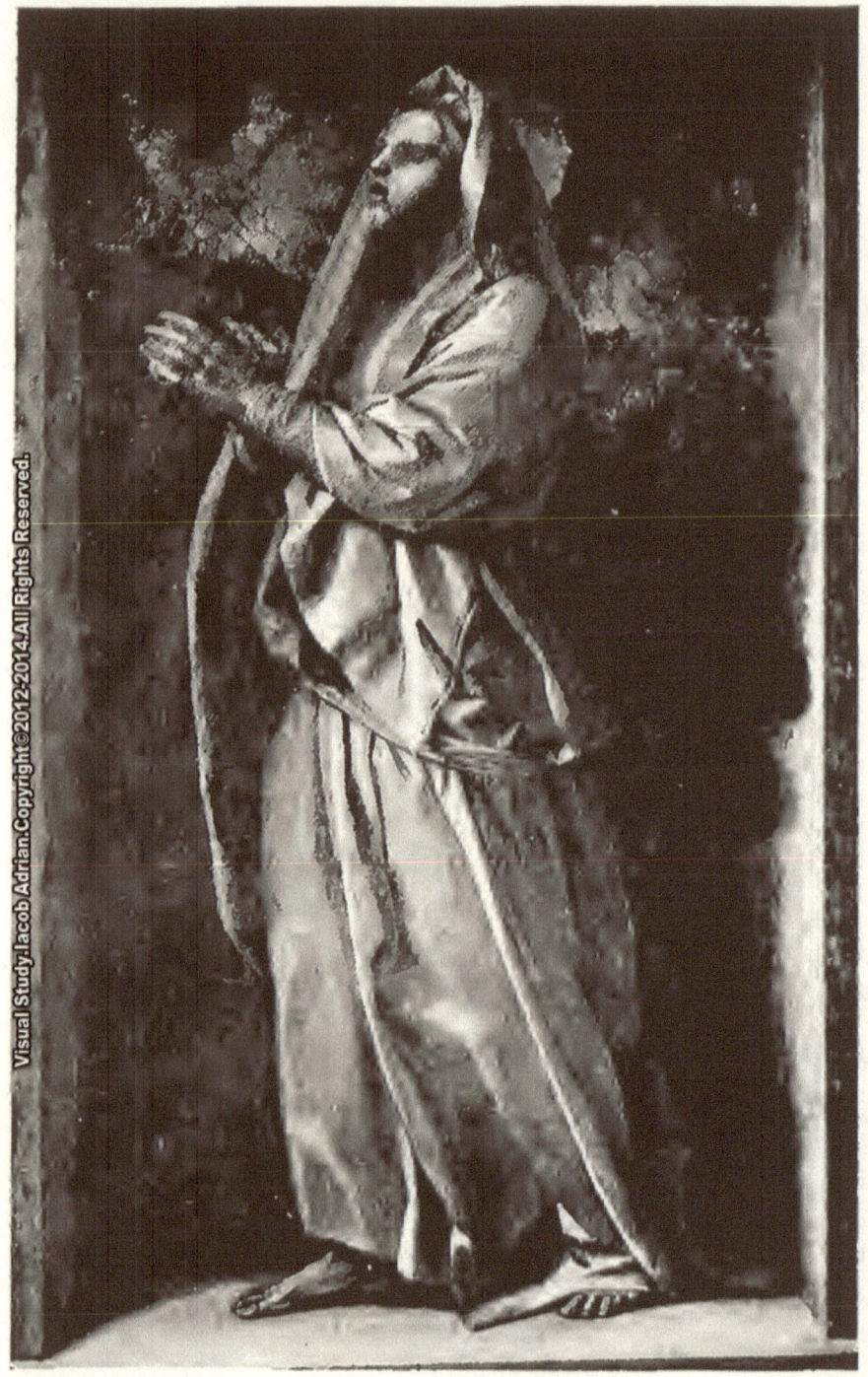

Hope (Fresco)
(Scalzo, Florence)

L'Espérance (Fresque)
(Scalzo, Florence)

Die Hoffnung (Freske)
(Florenz, Scalzo)

Frat. Alinari, Photo.

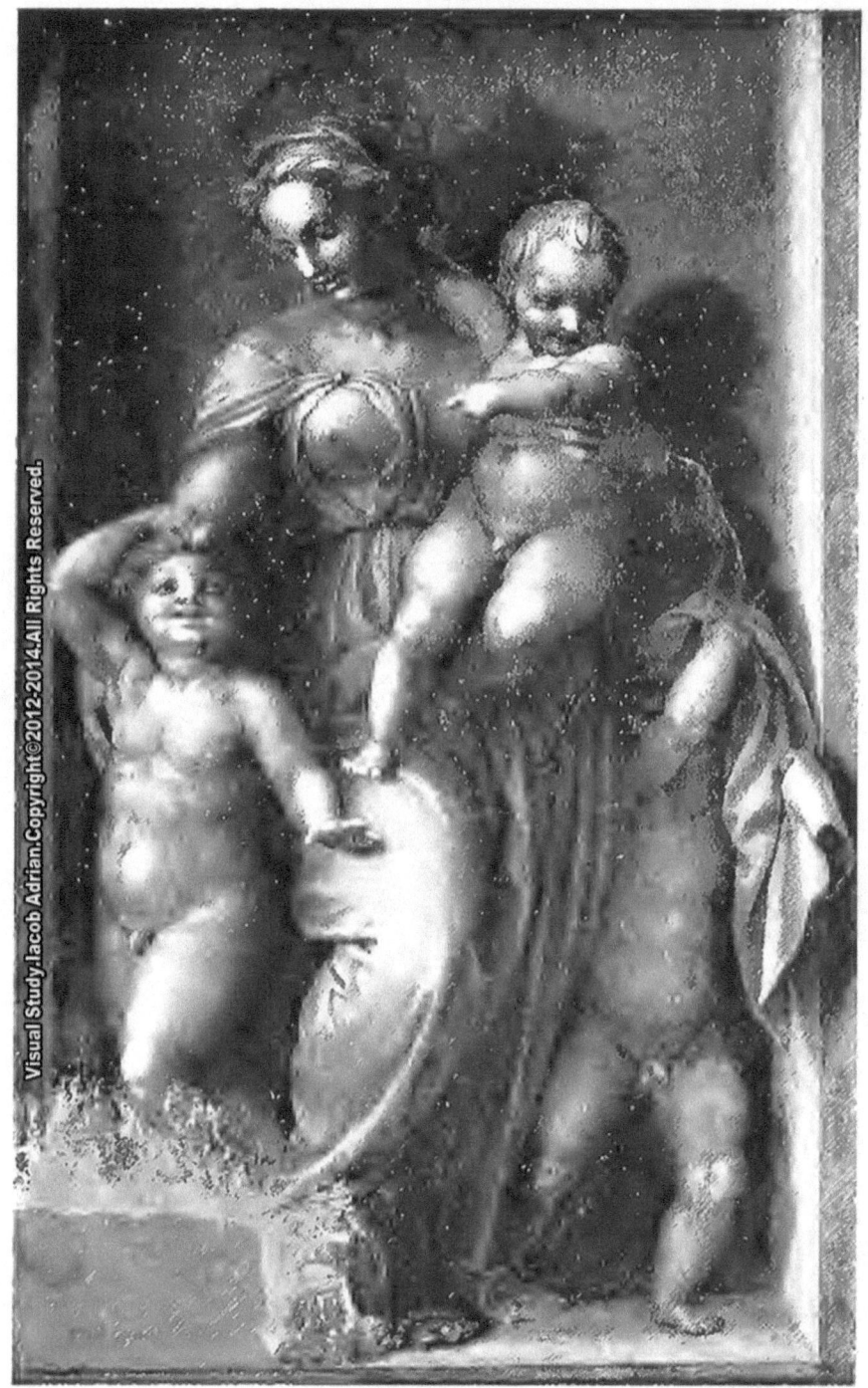

CHARITY (FRESCO) LA CHARITÉ (FRESQUE)
(*Scalzo, Florence*) (*Scalzo, Florence*)
 DIE BARMHERZIGKEIT (FRESKE)
 (*Florenz, Scalzo*) *Frat. Alinari, Photo.*

12

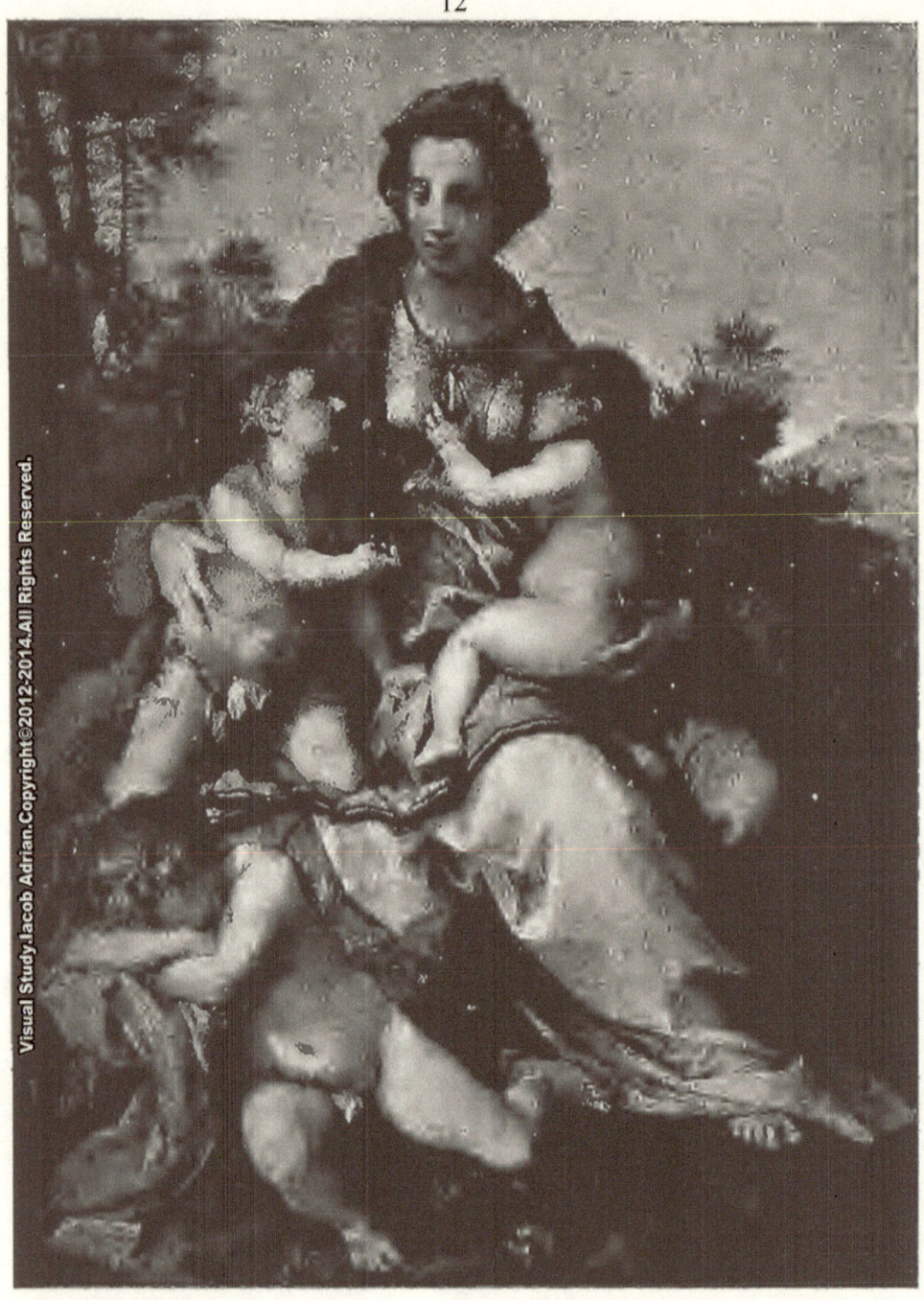

CHARITY
(*Louvre, Paris*)

DIE BARMHERZIGKEIT
(*Paris, Louvre*)
F. Hanfstaengl, Photo.

LA CHARITÉ
(*Louvre, Paris*)

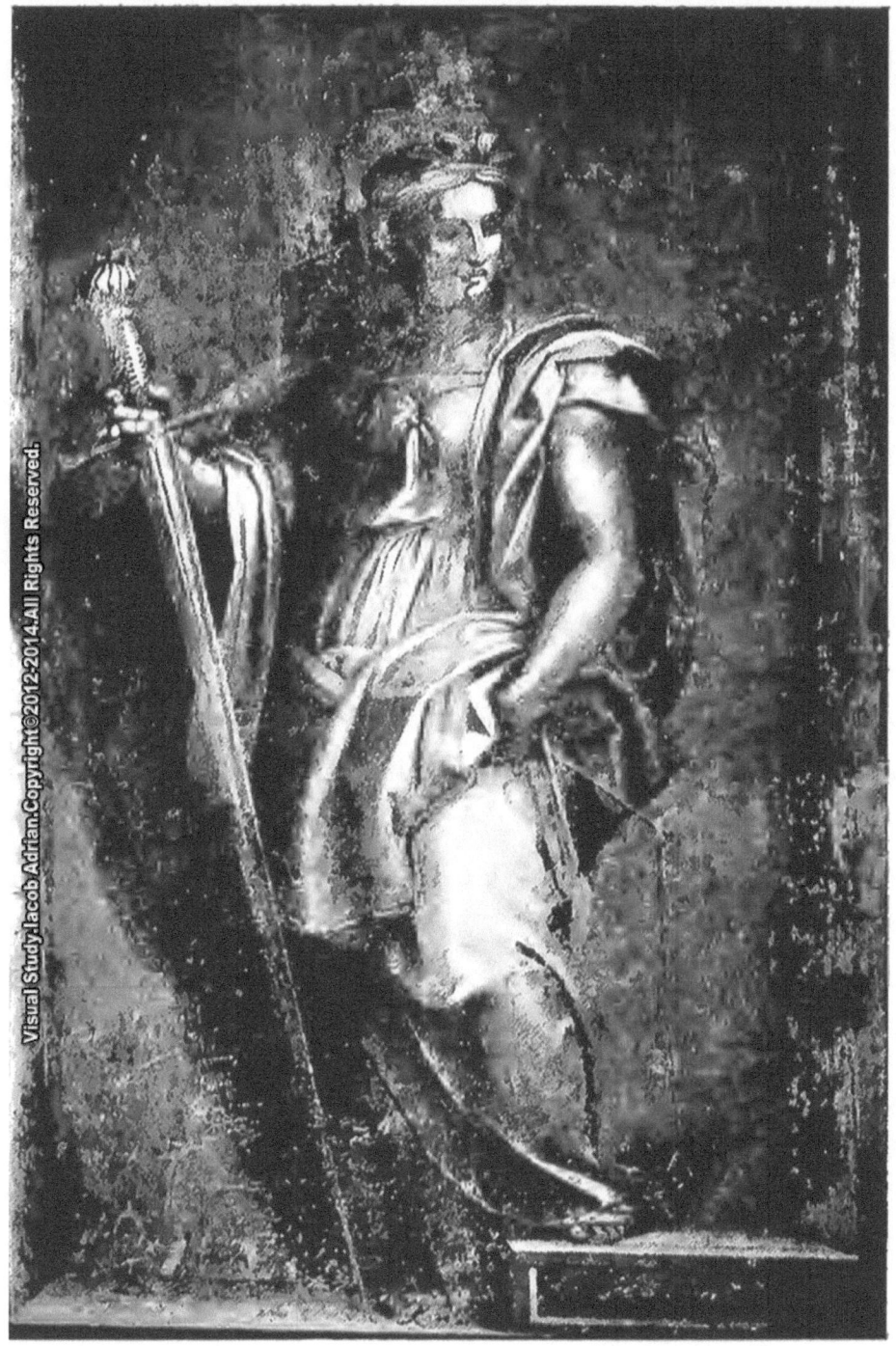

JUSTICE (FRESCO) LA JUSTICE (FRESQUE)
(*Scalzo, Florence*) (*Scalzo, Florence*)
 DIE GERECHTIGKEIT (FRESKE)
 (*Florenz, Scalzo*) Frat. Alinari, Photo.

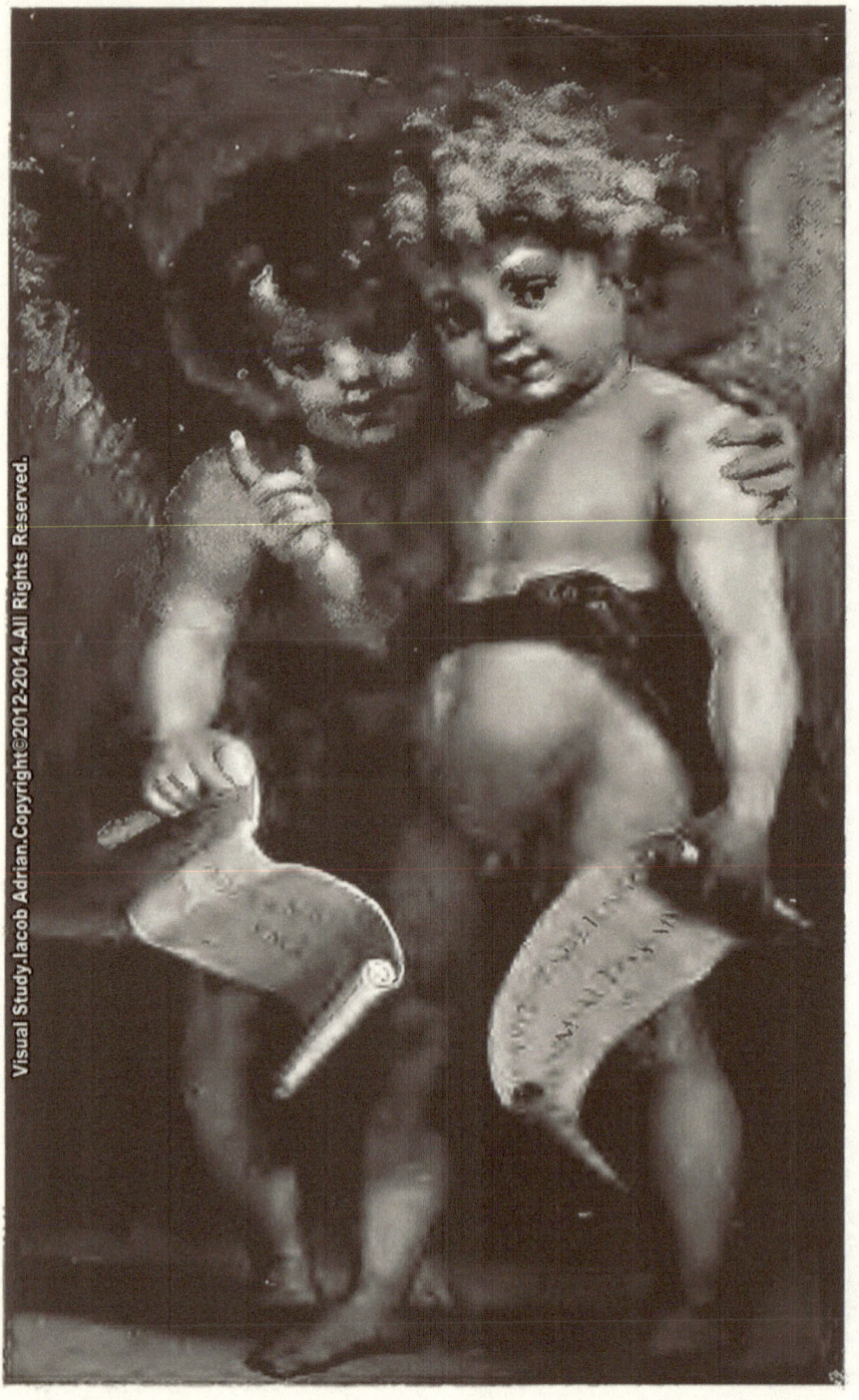

Two Cherubs
(Academy, Florence)

Deux Chérubins
(Académie, Florence)

Zwei Cherubs
(Florenz, Akademie)

D. Anderson, Photo.

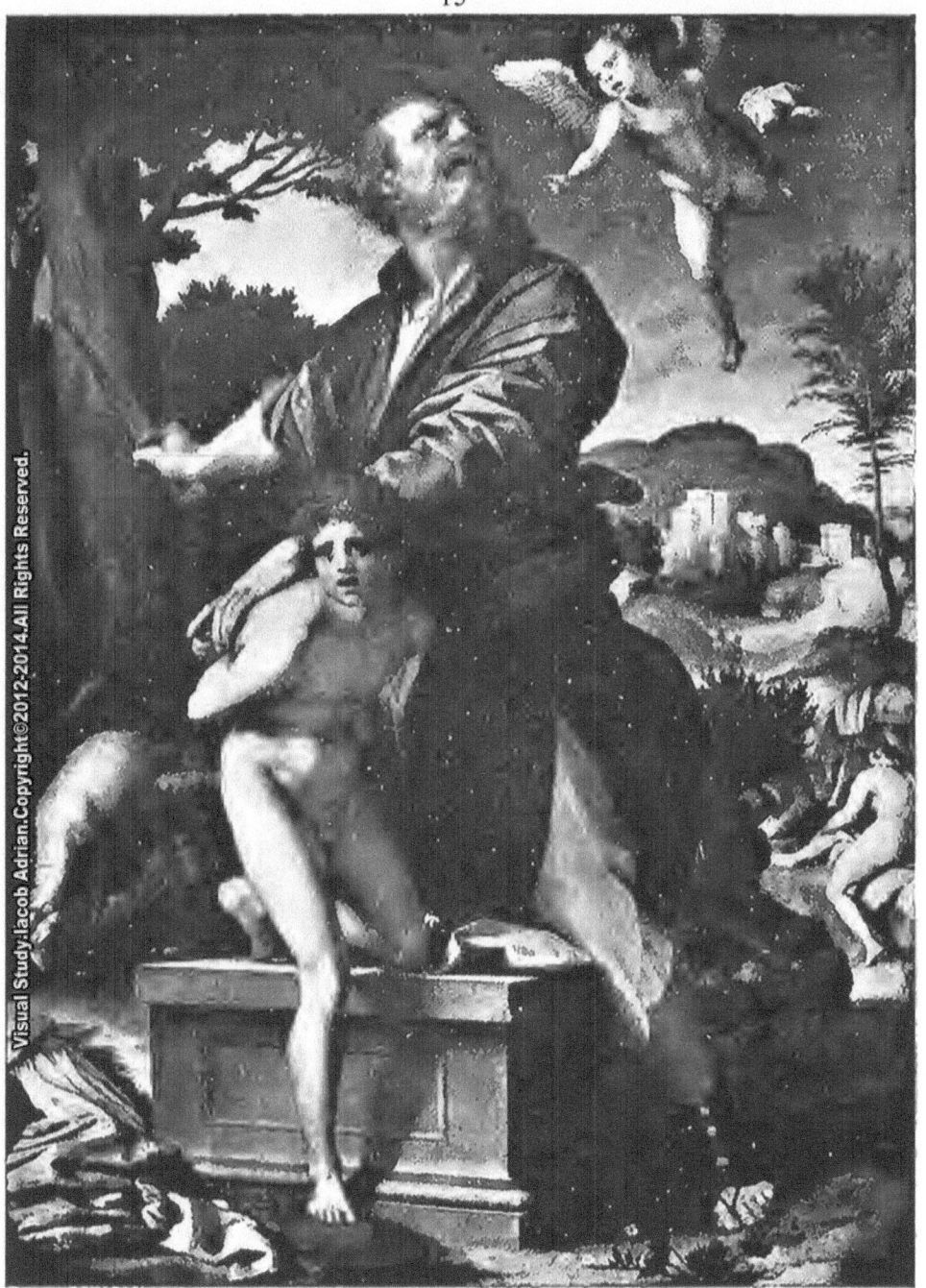

ABRAHAM'S SACRIFICE
(*Prado, Madrid*)

LE SACRIFICE D'ABRAHAM
(*Prado, Madrid*)

ABRAHAMS OPFER
(*Madrid, Prado*)
F. Hanfstaengl, Photo.

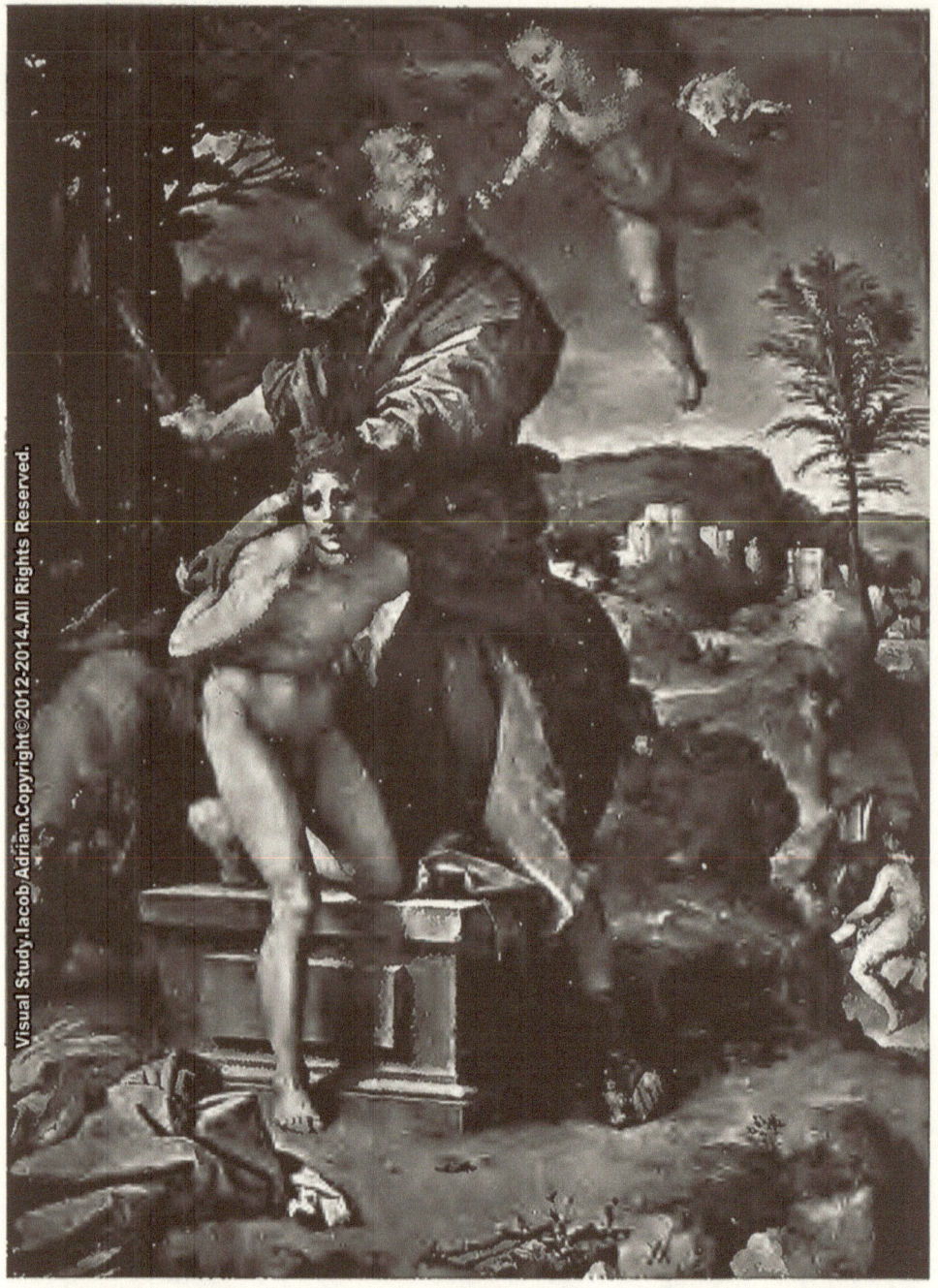

ABRAHAM'S SACRIFICE
(Royal Gallery, Dresden)

LE SACRIFICE D'ABRAHAM
(Galerie royale, Dresde)

ABRAHAMS OPFER
(Dresden, Kgl. Galerie)
F. Hanfstaengl, Photo.

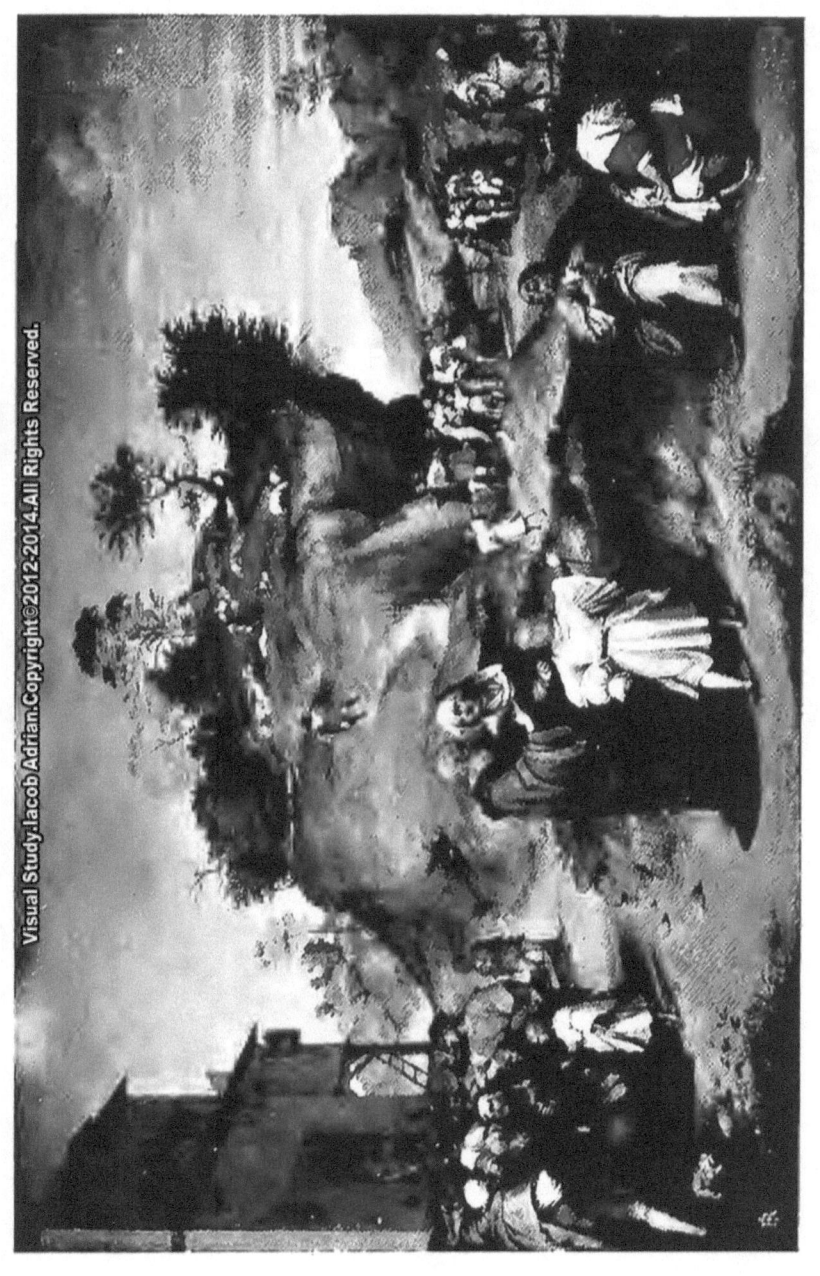

The Story of Joseph (I.)
(Pitti, Florence)

L'Histoire de Joseph (I.)
(Galerie Pitti, Florence)

Die Geschichte Josephs (I.)
(Florenz, Galerie Pitti)

D. Anderson, Photo.

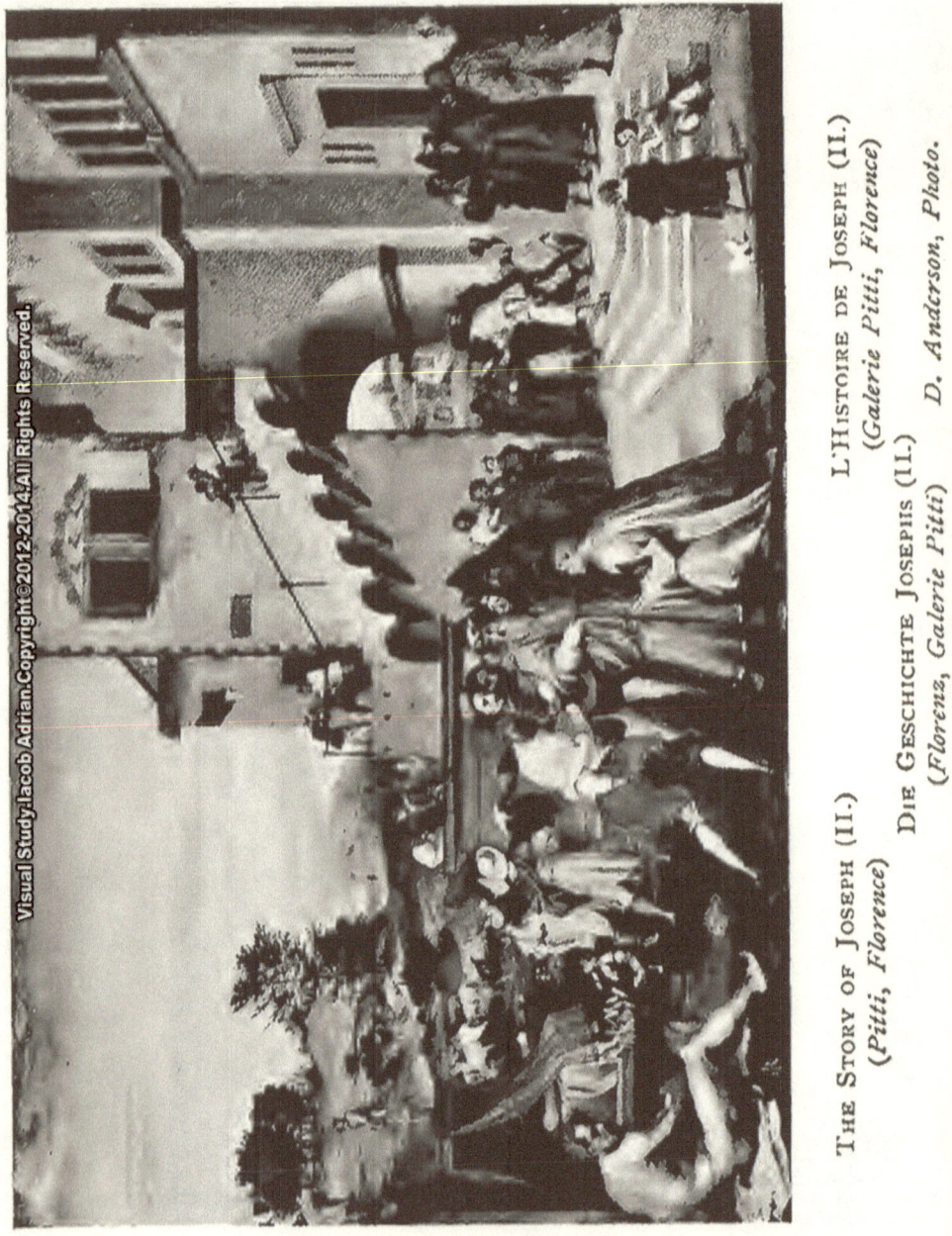

The Story of Joseph (II.)
(Pitti, Florence)

L'Histoire de Joseph (II.)
(Galerie Pitti, Florence)

Die Geschichte Josephs (II.)
(Florenz, Galerie Pitti)

D. Anderson, Photo.

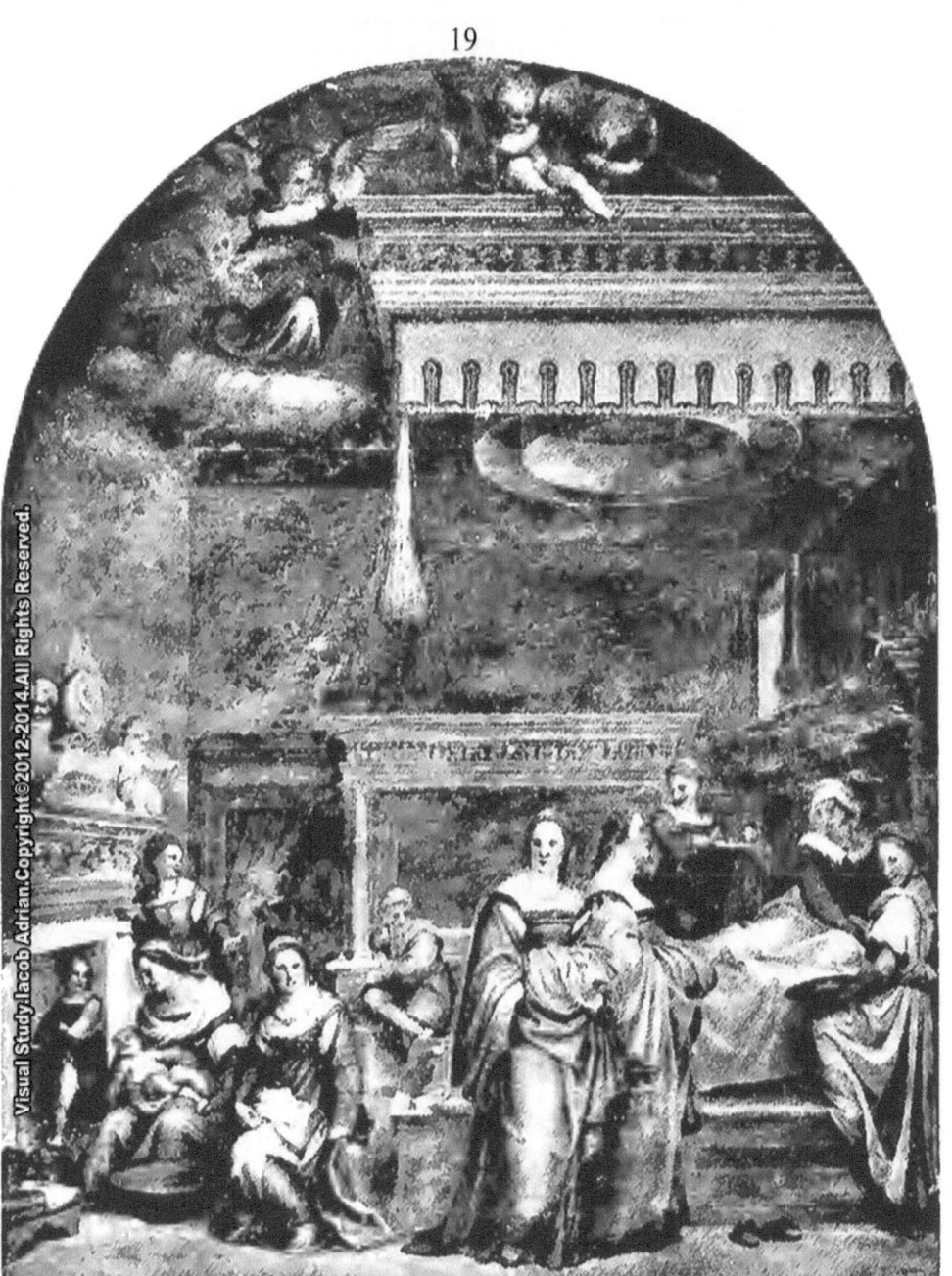

THE BIRTH OF THE VIRGIN (FRESCO)
(SS. Annunziata, Florence)

LA NAISSANCE DE LA VIERGE (FRESQUE)
(SS. Annunziata, Florence)

MARIÄ GEBURT (FRESKE)
(Florenz, SS. Annunziata)

D. Anderson, Photo.

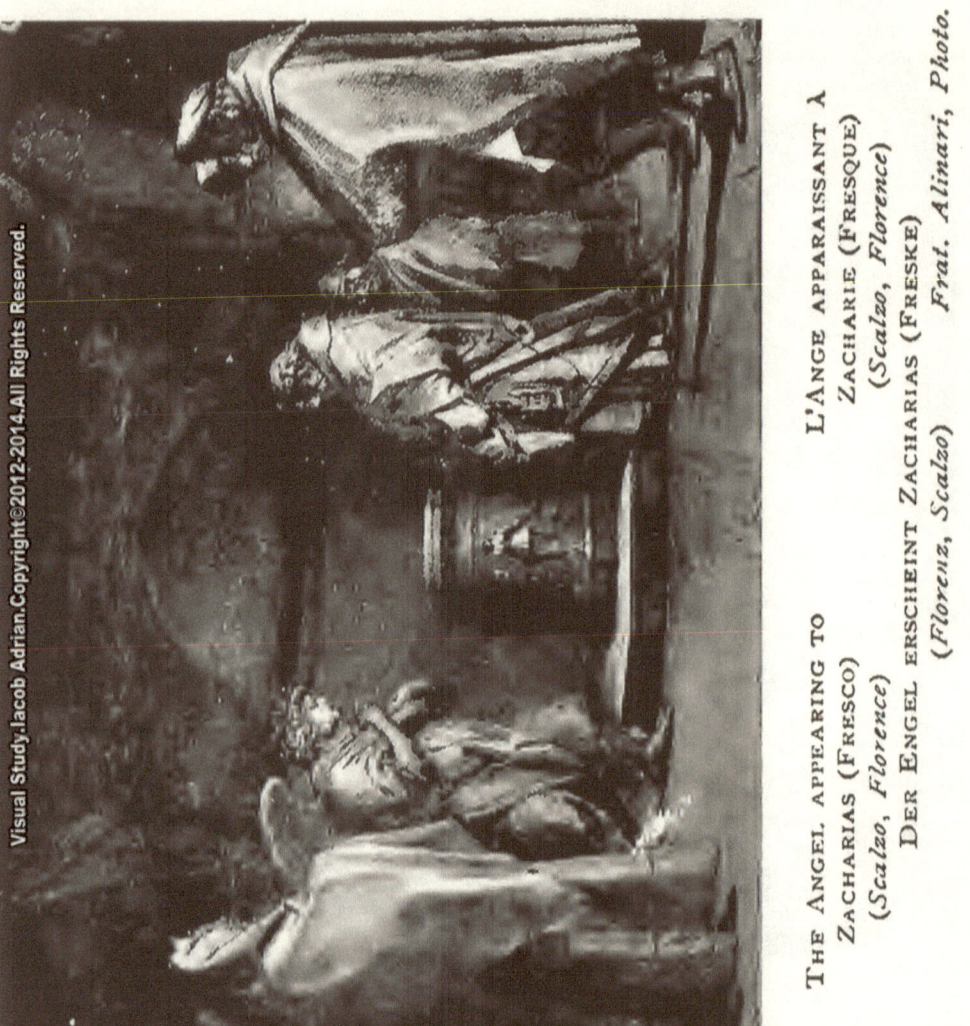

The Angel appearing to Zacharias (Fresco)
(Scalzo, Florence)

L'Ange apparaissant à Zacharie (Fresque)
(Scalzo, Florence)

Der Engel erscheint Zacharias (Freske)
(Florenz, Scalzo)

Frat. Alinari, Photo.

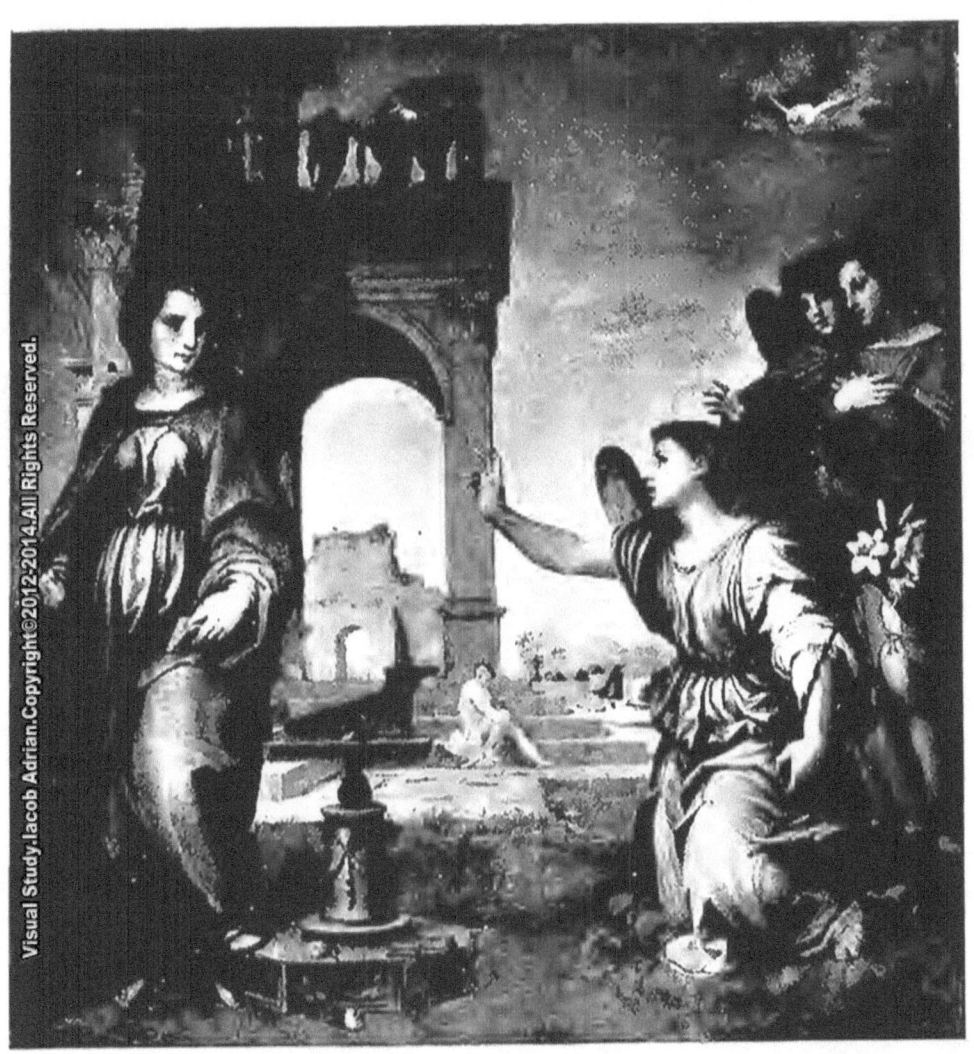

THE ANNUNCIATION
(*Pitti, Florence*)

L'ANNONCIATION
(*Galerie Pitti, Florence*)

DIE VERKÜNDIGUNG
(*Florenz, Galerie Pitti*)
F. Hanfstaengl, Photo.

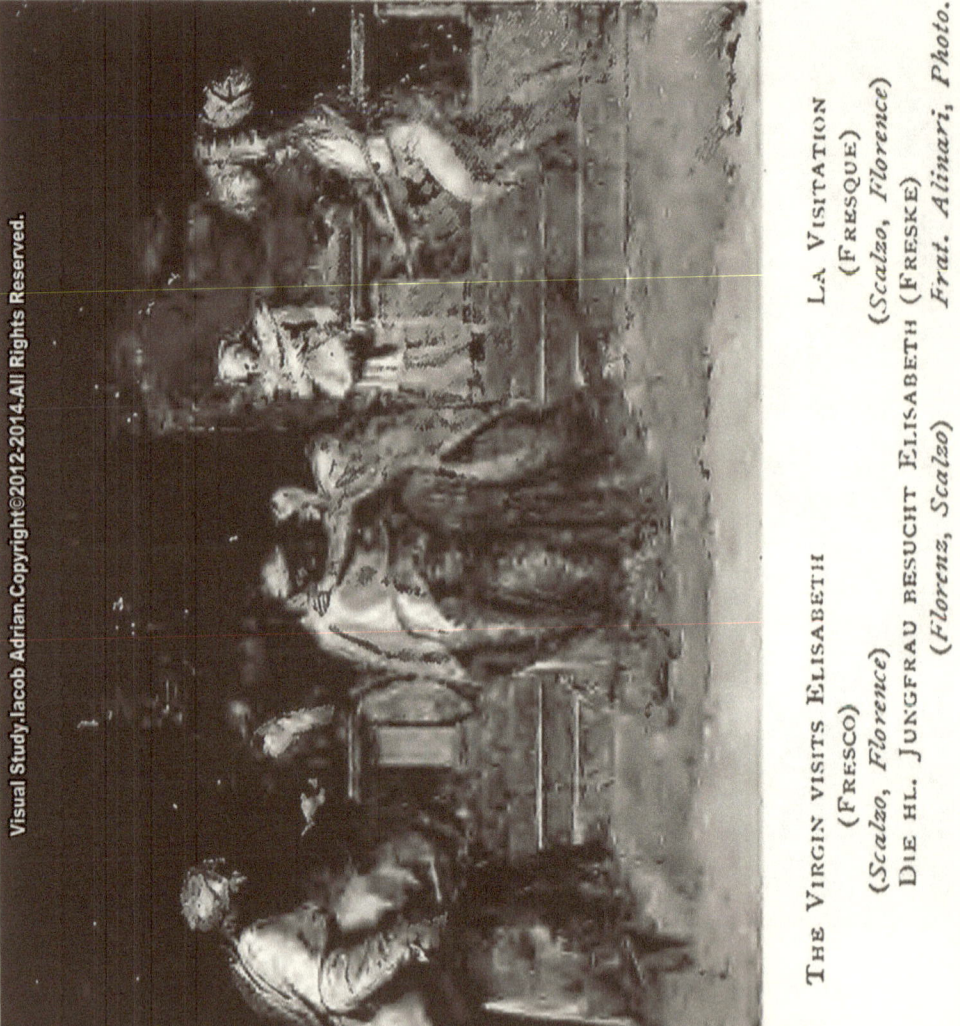

The Virgin visits Elisabeth
(Fresco)
(Scalzo, Florence)

La Visitation
(Fresque)
(Scalzo, Florence)

Die hl. Jungfrau besucht Elisabeth (Freske)
(Florenz, Scalzo) *Frat. Alinari, Photo.*

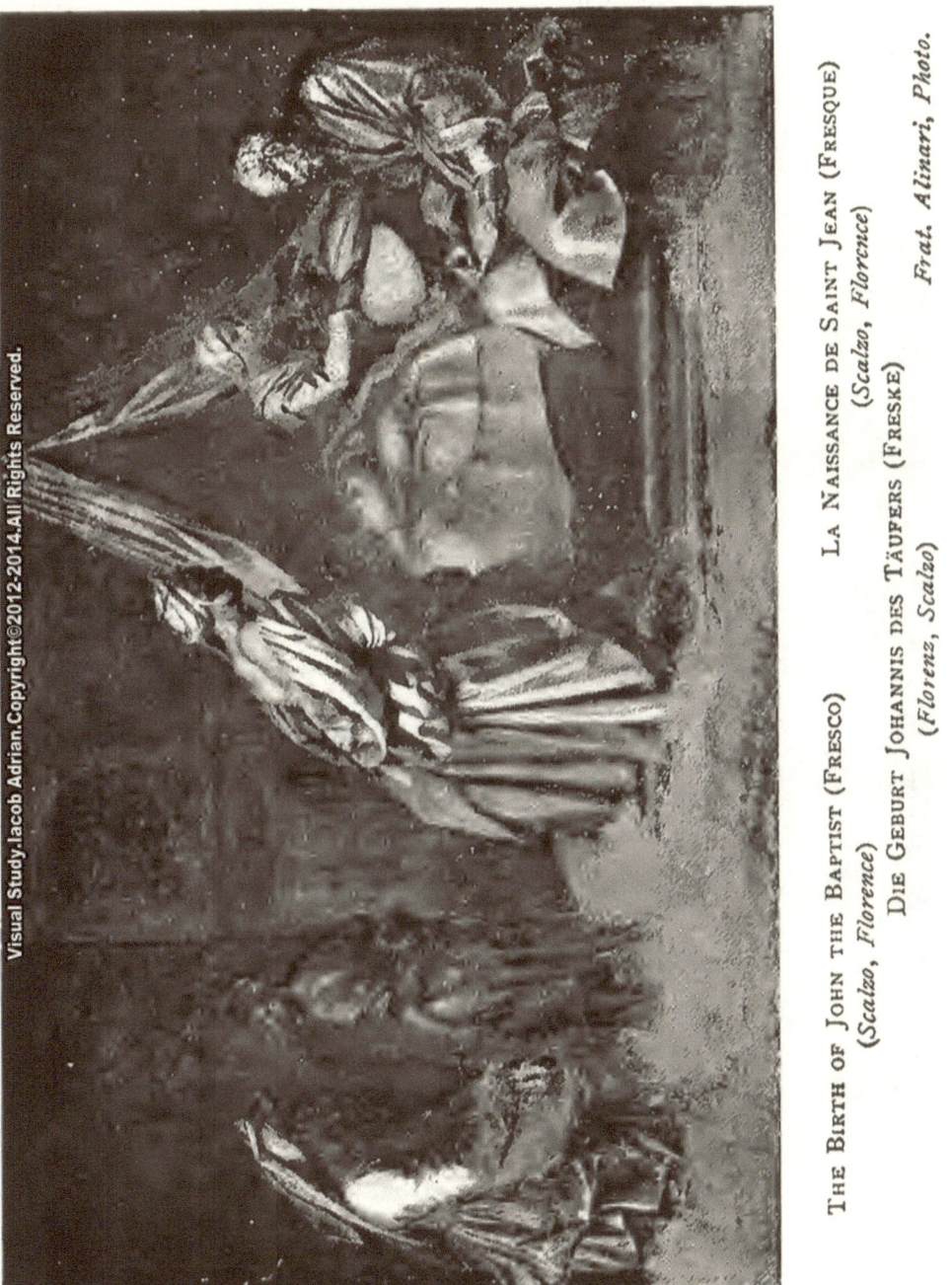

The Birth of John the Baptist (Fresco)　　La Naissance de Saint Jean (Fresque)
(Scalzo, Florence)　　(Scalzo, Florence)
Die Geburt Johannis des Täufers (Freske)
(Florenz, Scalzo)

Frat. Alinari, Photo.

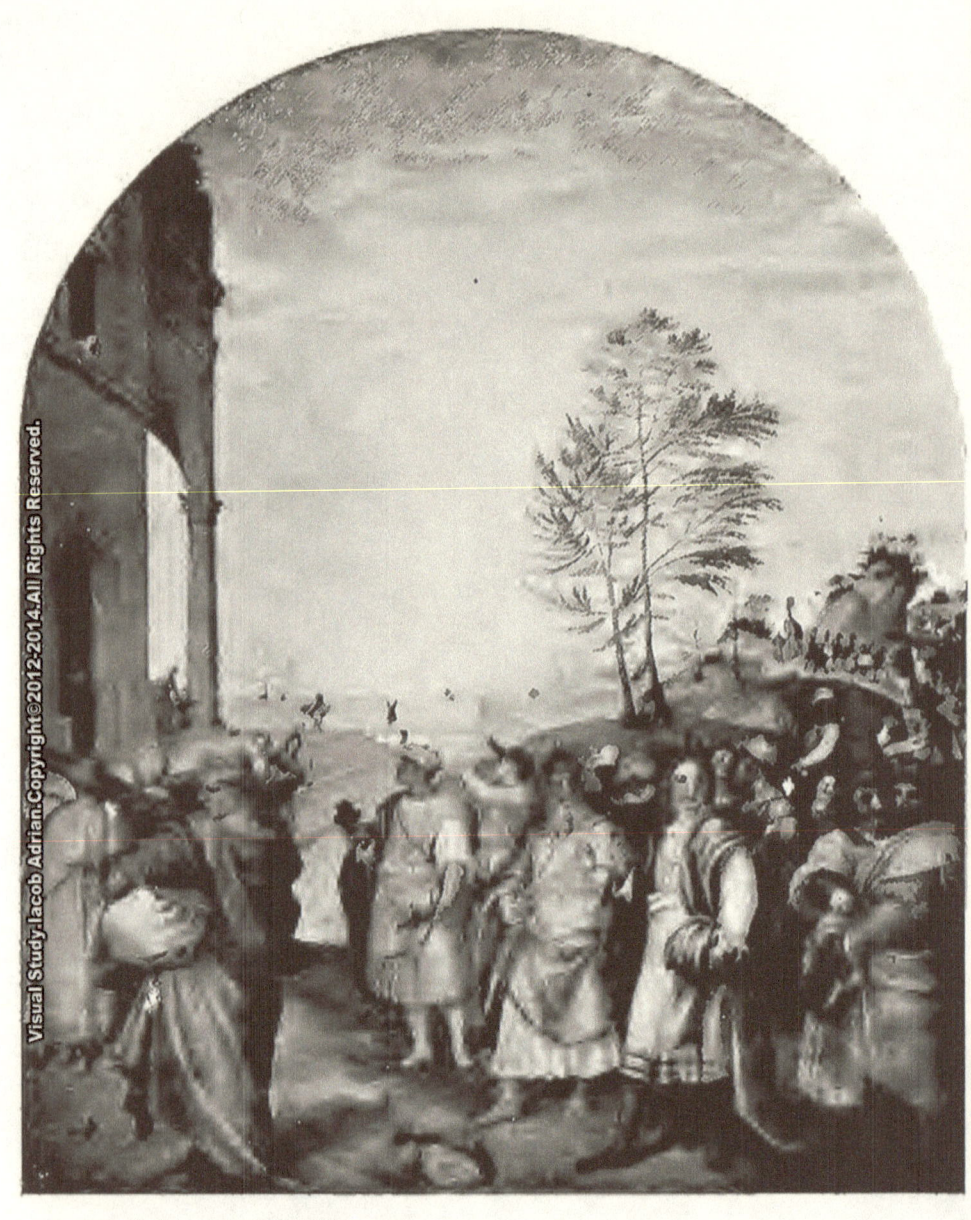

ADORATION OF THE MAGI (FRESCO)
(SS. Annunziata, Florence)

L'ADORATION DES MAGES (FRESQUE)
(SS. Annunziata, Florence)

DIE ANBETUNG DER WEISEN (FRESKE)
(Florenz, SS. Annunziata)

G. Brogi, Photo.

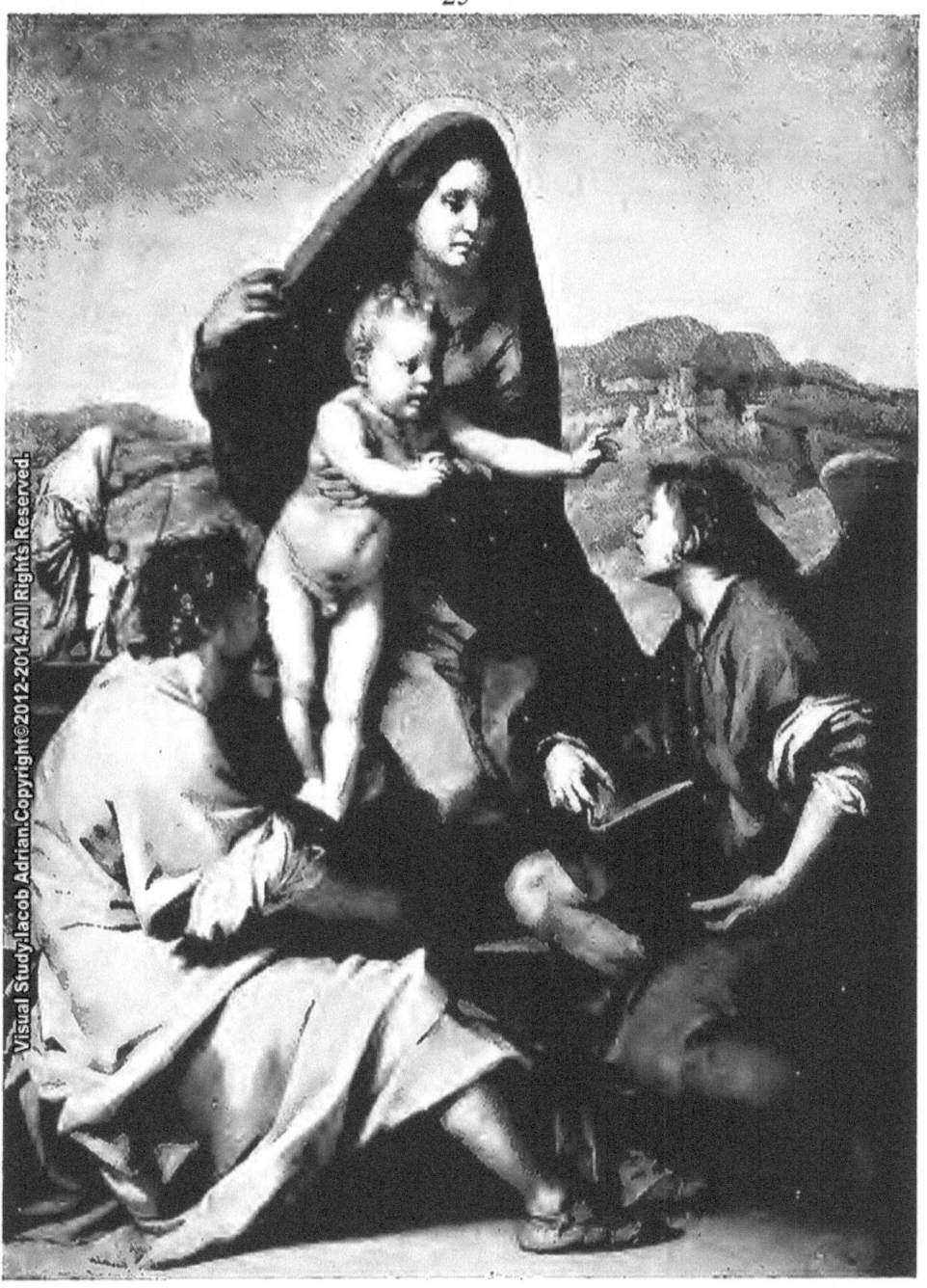

THE HOLY FAMILY
(*Prado, Madrid*)

DIE HEILIGE FAMILIE
(*Madrid, Prado*)
F. Hanfstaengl, Photo.

LA SAINTE FAMILLE
(*Prado, Madrid*)

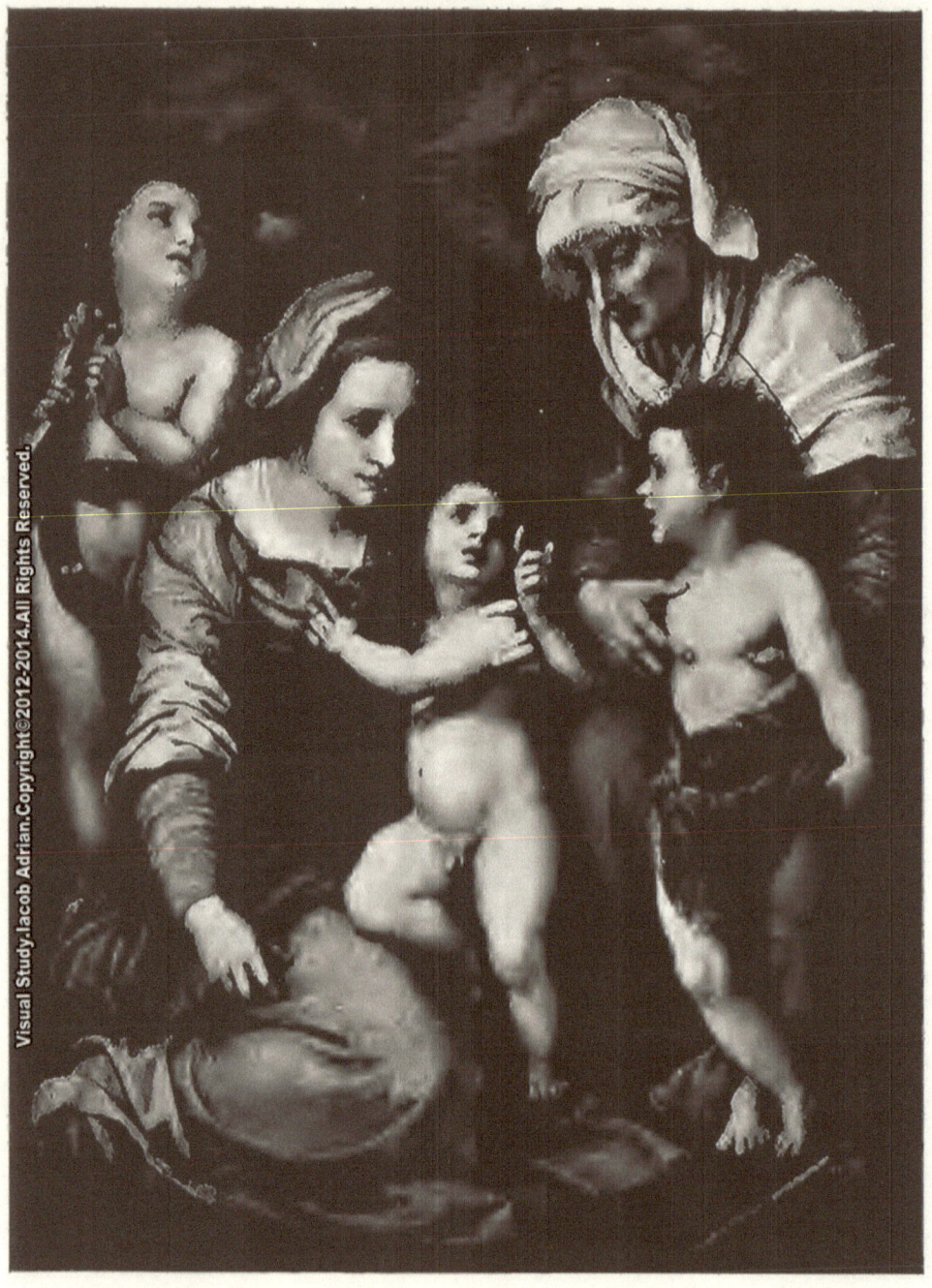

THE HOLY FAMILY
(*Pinacotheca, Munich*)

LA SAINTE FAMILLE
(*Pinacothèque, Munich*)

DIE HEILIGE FAMILIE
(*München, Pinakothek*)
F. Hanfstaengl, Photo.

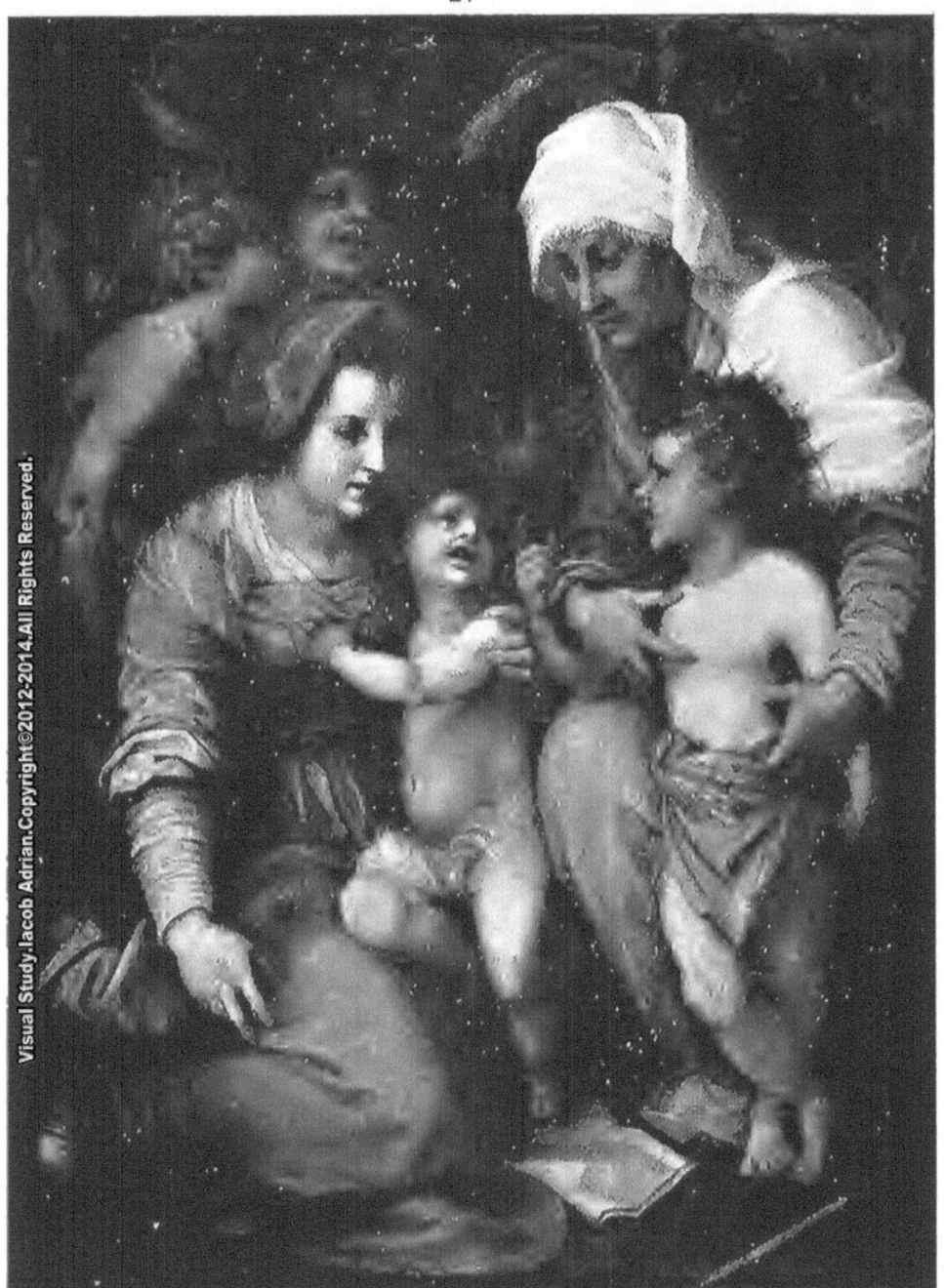

THE HOLY FAMILY
(*Louvre, Paris*)

LA SAINTE FAMILLE
(*Louvre, Paris*)

DIE HEILIGE FAMILIE
(*Paris, Louvre*)
Neuerdein Frères, Photo.

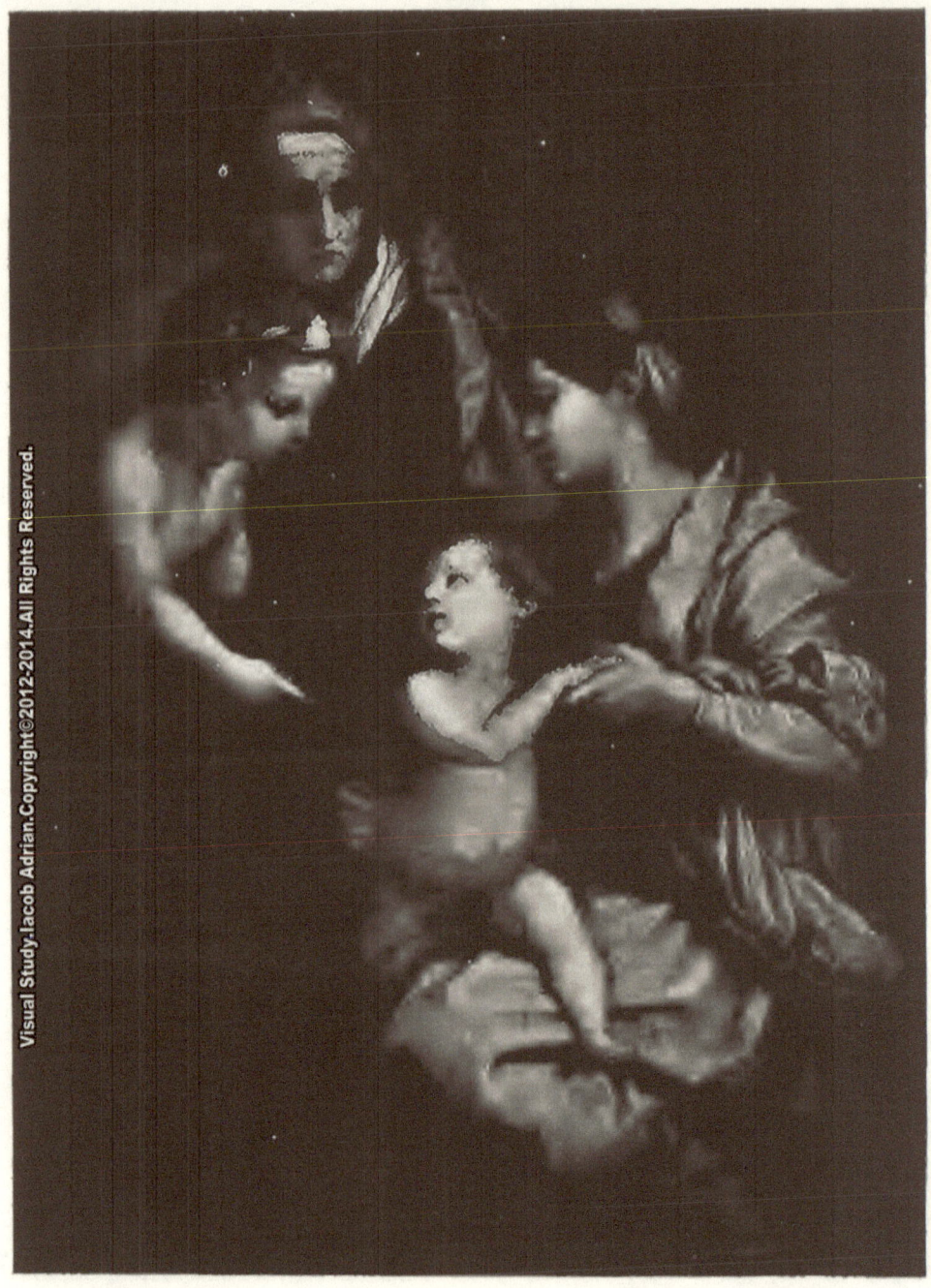

THE HOLY FAMILY
(*Pitti, Florence*)

LA SAINTE FAMILLE
(*Galerie Pitti, Florence*)

DIE HEILIGE FAMILIE
(*Florenz, Galerie Pitti*)
F. Hanfstaengl, Photo.

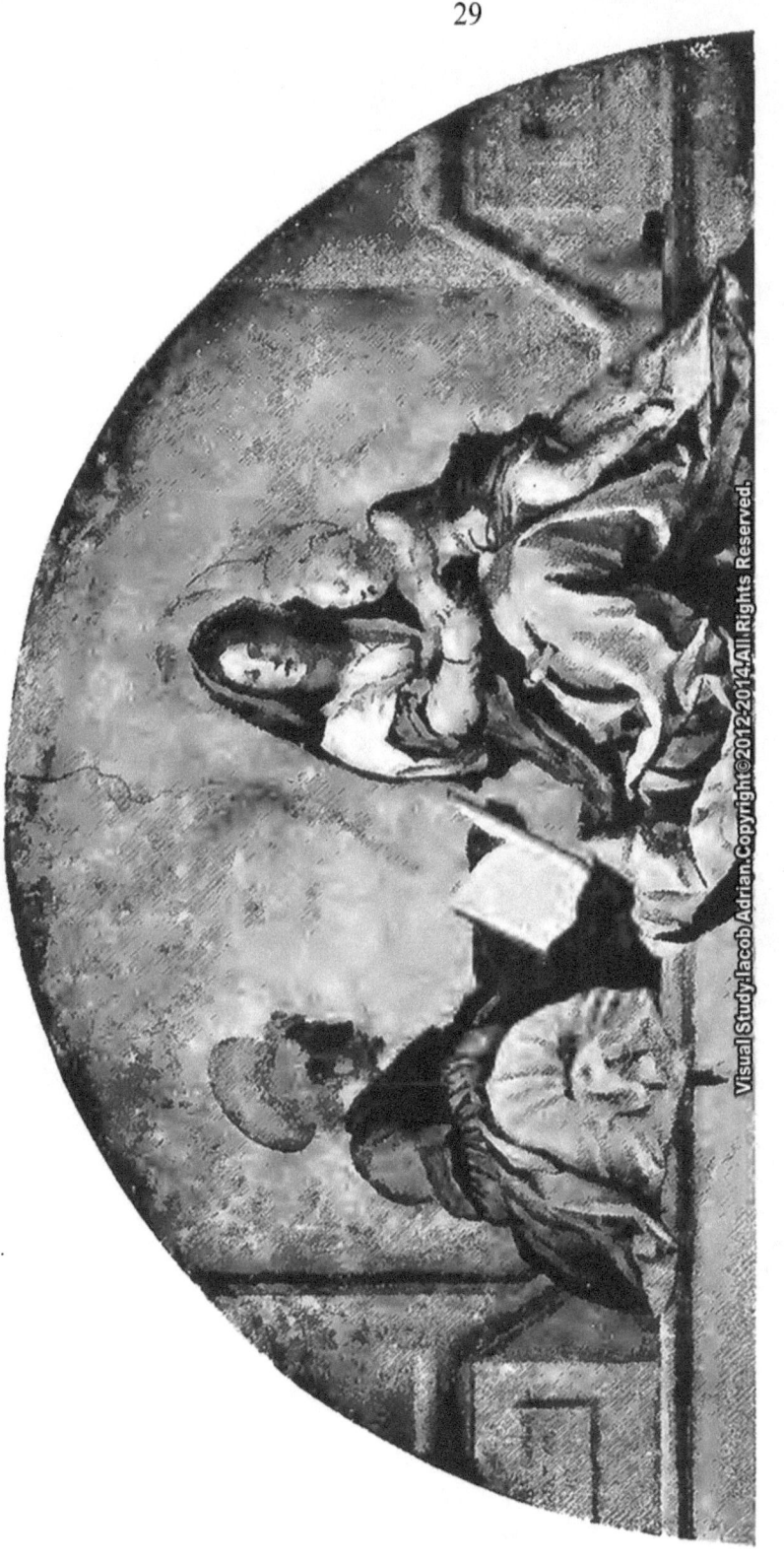

THE HOLY FAMILY ("MADONNA DEL SACCO") DIE HEILIGE FAMILIE LA SAINTE FAMILLE
(FRESCO) (FRESKE) (FRESQUE)
(SS. Annunziata, Florence) (Florenz, SS. Annunzia:a) (SS. Annunziata, Florence)

D. Anderson, Photo.

30

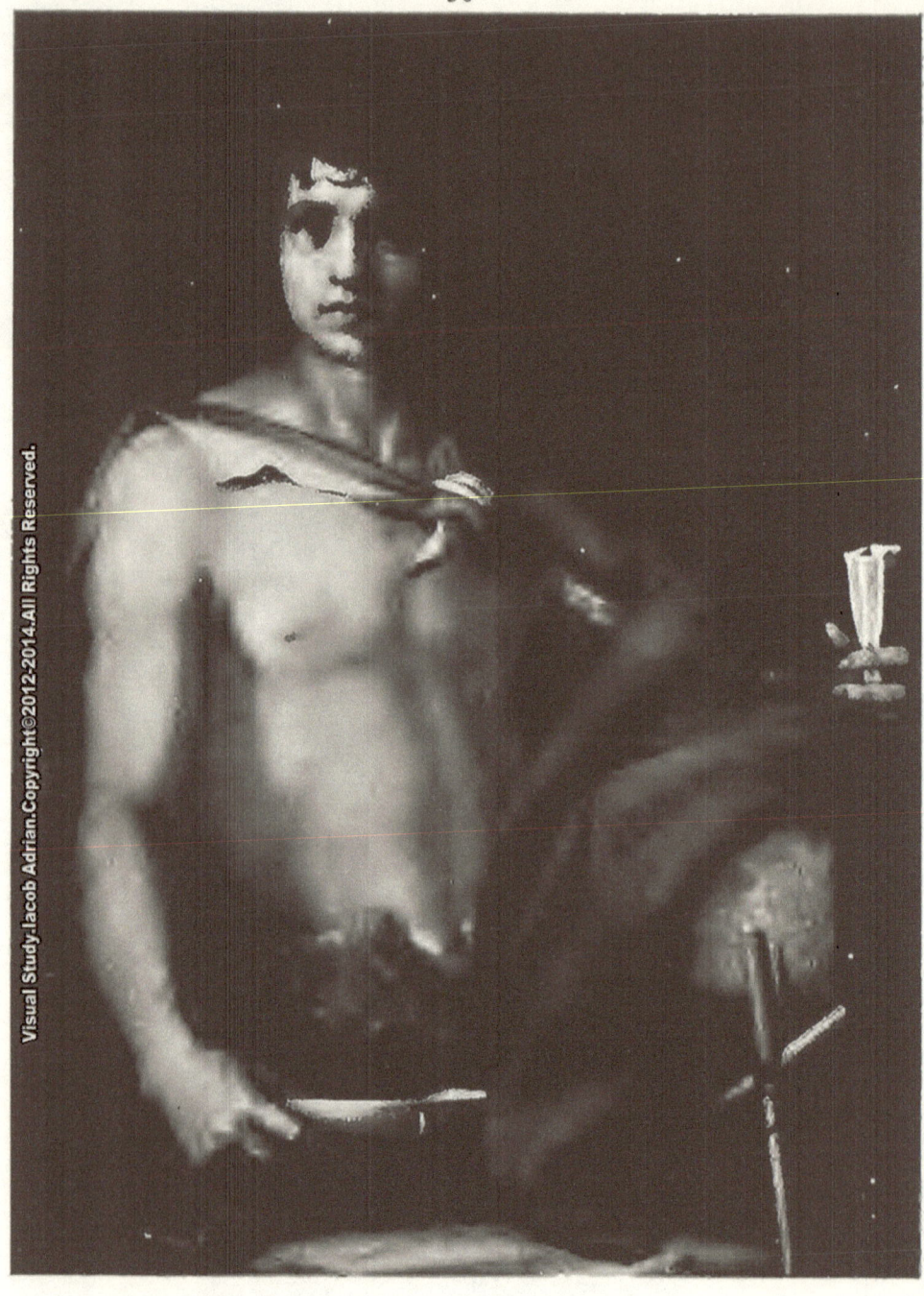

JOHN THE BAPTIST SAINT JEAN-BAPTISTE
(*Pitti, Florence*) (*Galerie Pitti, Florence*)
ST. JOHANNES DER TÄUFER
(*Florenz, Galerie Pitti*)
F. *Hanfstaengl*, Photo.

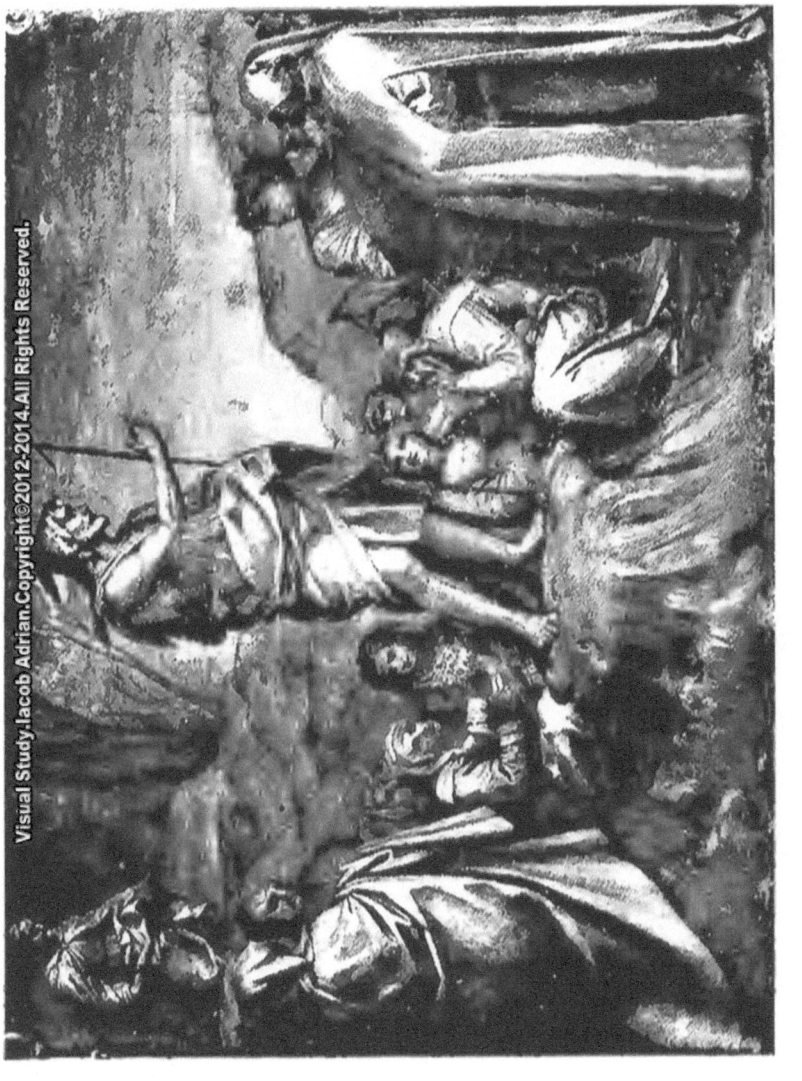

John the Baptist preaching to the People (Fresco)
(Scalzo, Florence)
St. Johannes dem Volke predigend (Freske)
(Florenz, Scalzo)

La Prédication de Saint Jean (Fresque)
(Scalzo, Florence)

Frat. Alinari, Phot.

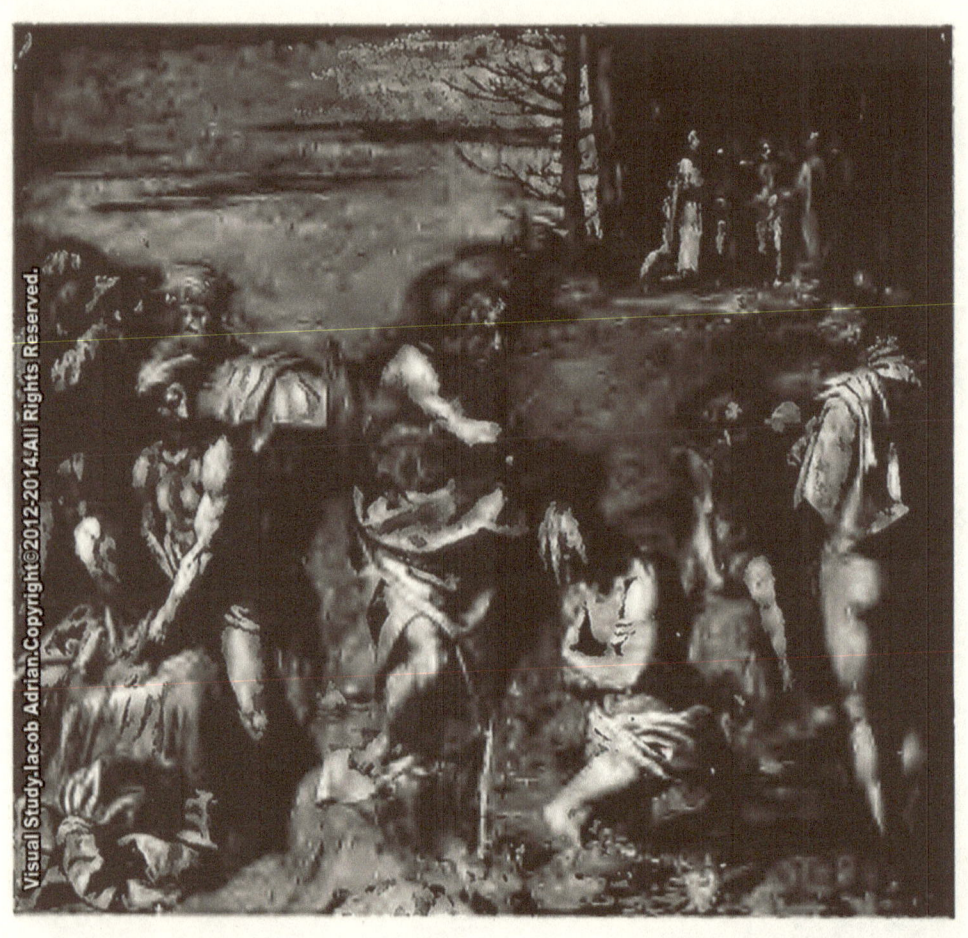

John the Baptist baptizing the People (Fresco)
(*Scalzo, Florence*)
Saint Jean baptisant la Foule (Fresque)
(*Scalzo, Florence*)
St. Johannes das Volk taufend (Freske)
(*Florenz, Scalzo*)

Frat. Alinari, Photo.

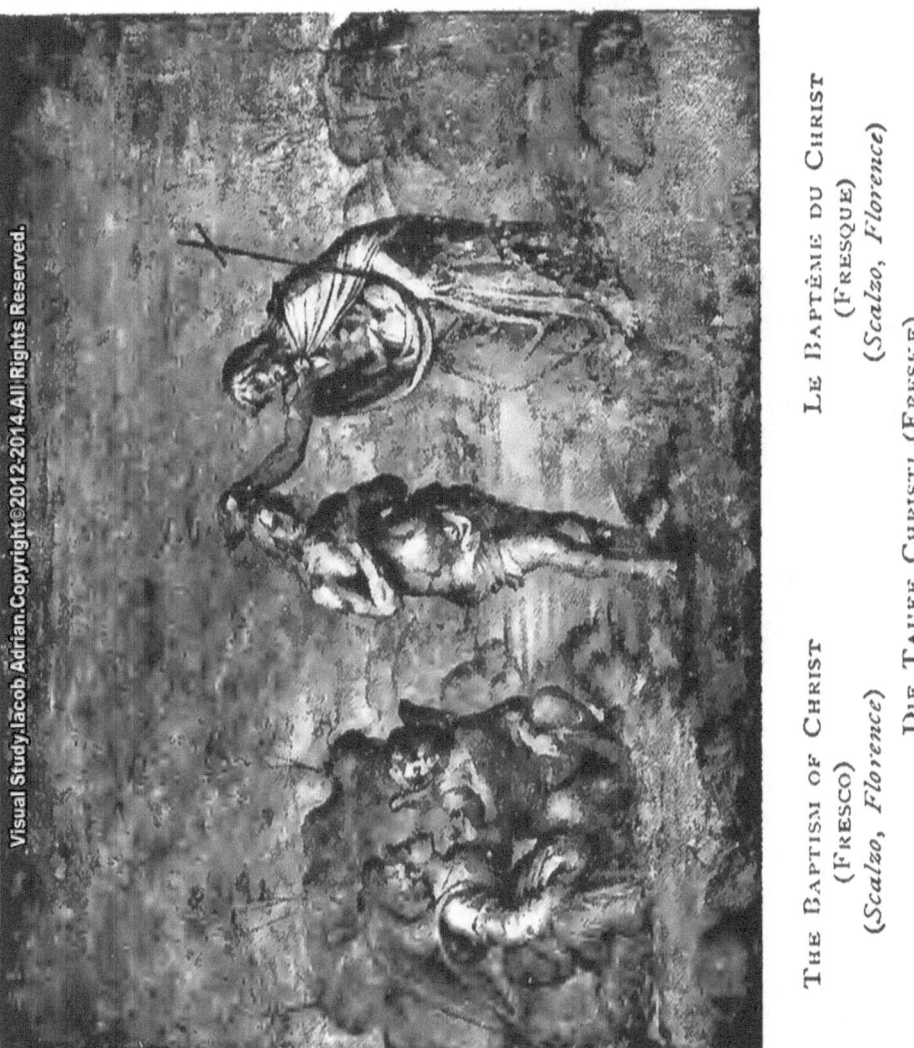

The Baptism of Christ (Fresco)
(Scalzo, Florence)

Le Baptême du Christ (Fresque)
(Scalzo, Florence)

Die Taufe Christi (Freske)
(Florenz, Scalzo)

Frat. Alinari, Photo.

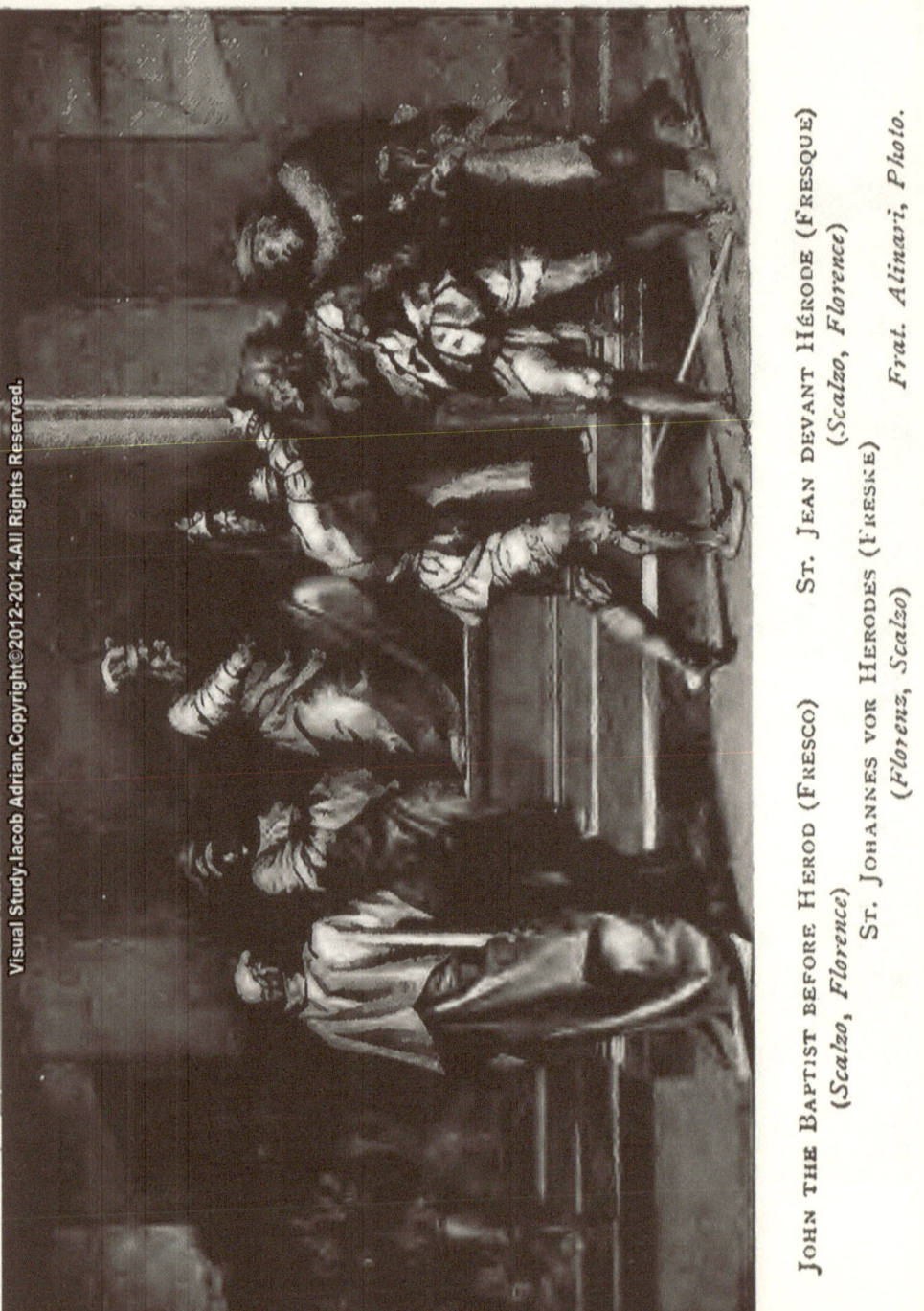

John the Baptist before Herod (Fresco)
(Scalzo, Florence)
St. Jean devant Hérode (Fresque)
(Scalzo, Florence)
St. Johannes vor Herodes (Freske)
(Florenz, Scalzo)

Frat. Alinari, Photo.

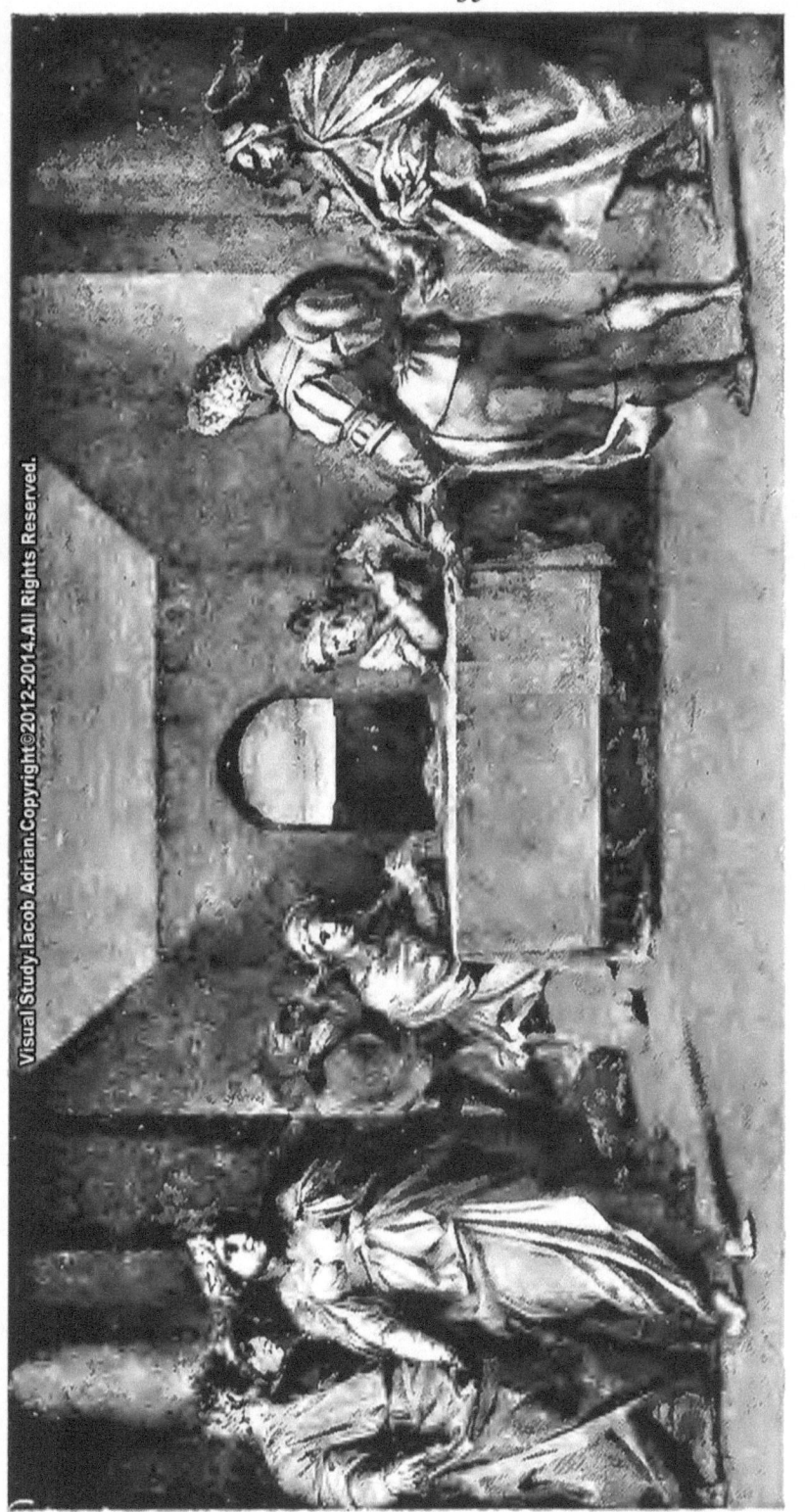

SALOME DANCING (FRESCO) (Scalzo, Florence)

SALOME TANZEND (FRESKE) (Florenz, Scalzo) Frat. Alinari, Photo.

SALOMÉ DANSANT (FRESQUE) (Scalzo, Florence)

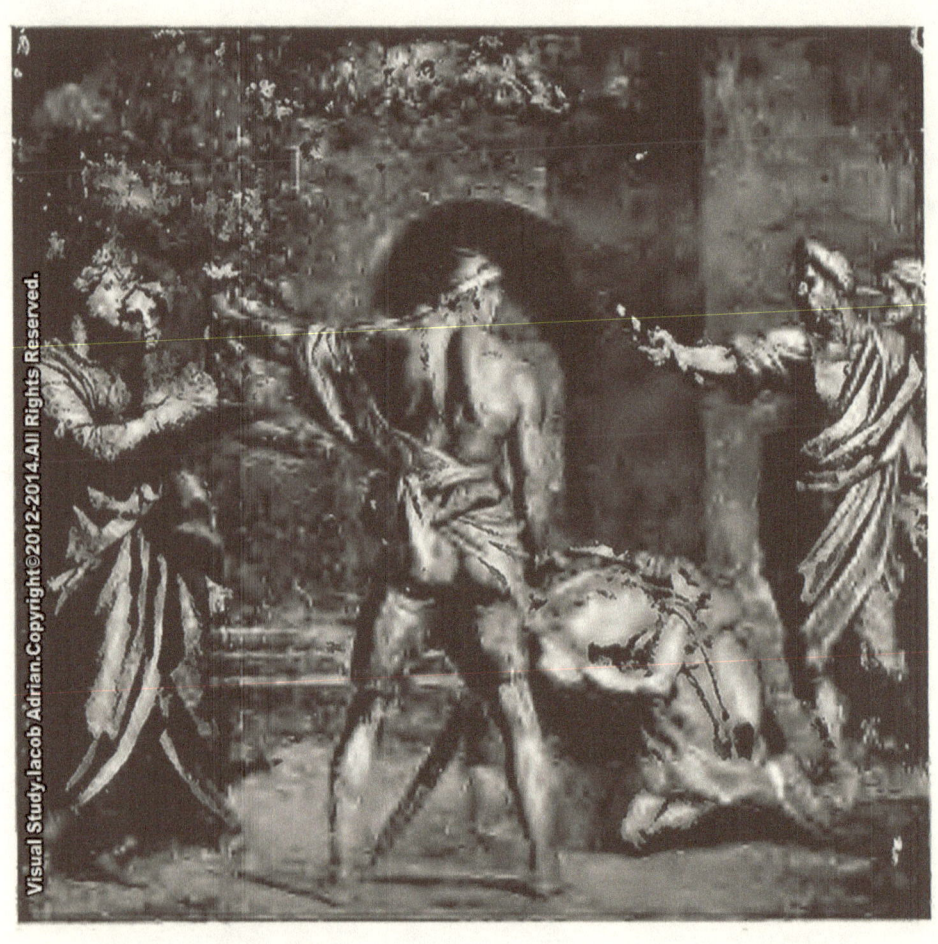

The Decapitation of
John the Baptist (Fresco)
(*Scalzo, Florence*)

La Décollation de
Saint Jean (Fresque)
(*Scalzo, Florence*)

Die Enthauptung Johannis (Freske)
(*Florenz, Scalzo*) Frat. Alinari, Photo.

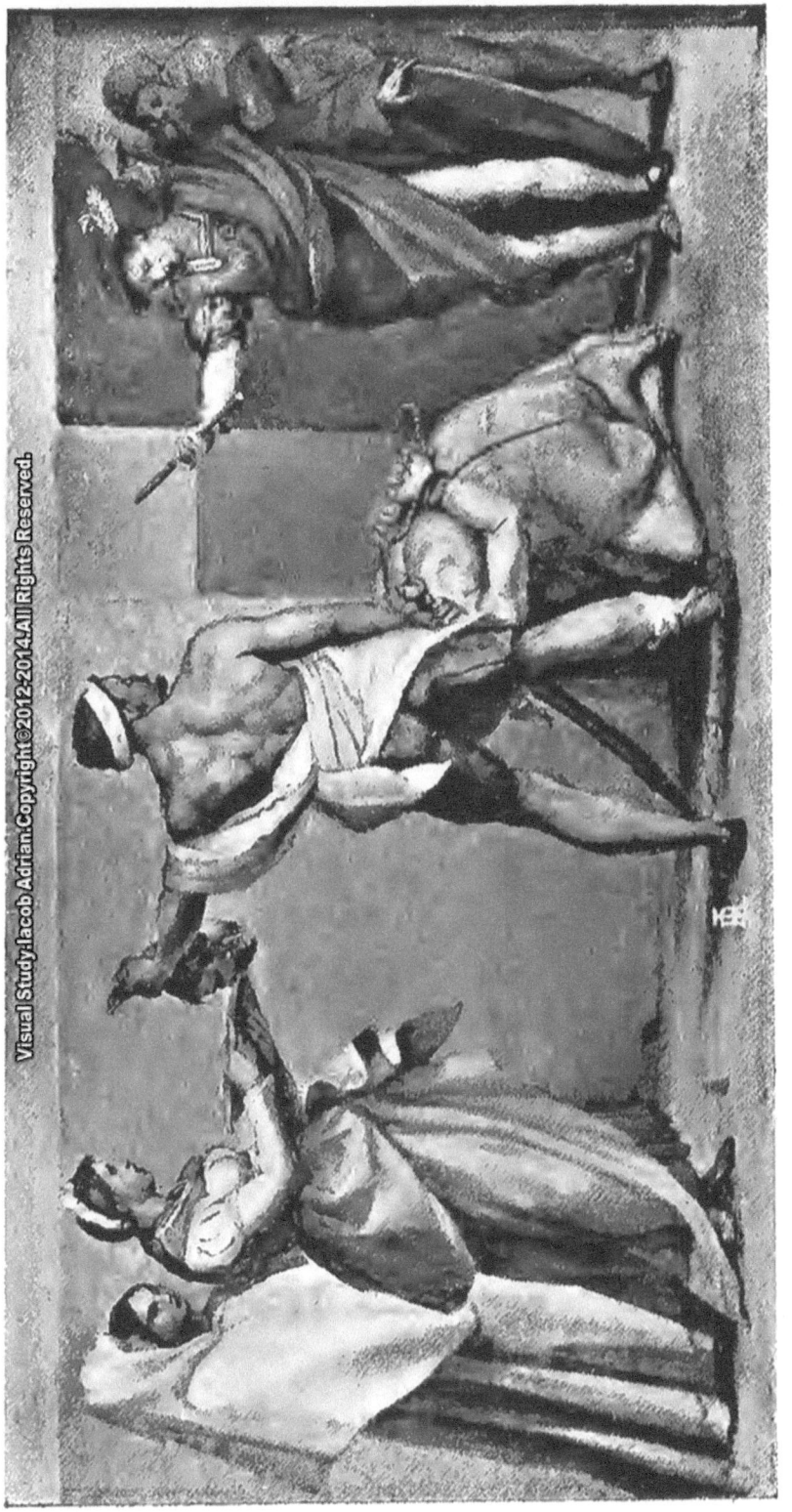

The Decapitation of John the Baptist [Predella] La Décollation de Saint Jean
(Academy, Florence) (Académi., Florence)

Die Enthauptung Johannis
(Florenz, Akademie)

Frat. Alinari, Photo.

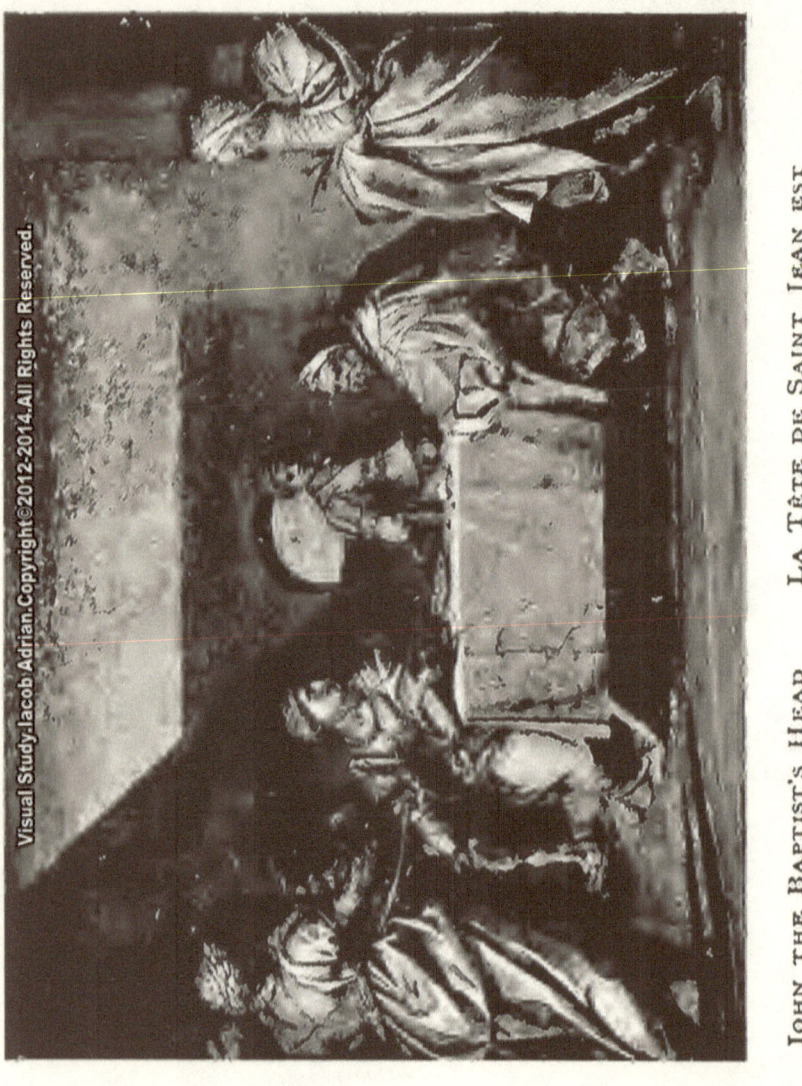

John the Baptist's Head presented to Herodias (Fresco)
(Scalzo, Florence)
La Tête de Saint Jean est presentée à Hérodiade (Fresque)
(Scalzo, Florence)
Der Kopf Johannis wird Herodias dargereicht (Freske)
(Florenz, Scalzo) *Frat. Alinari, Photo.*

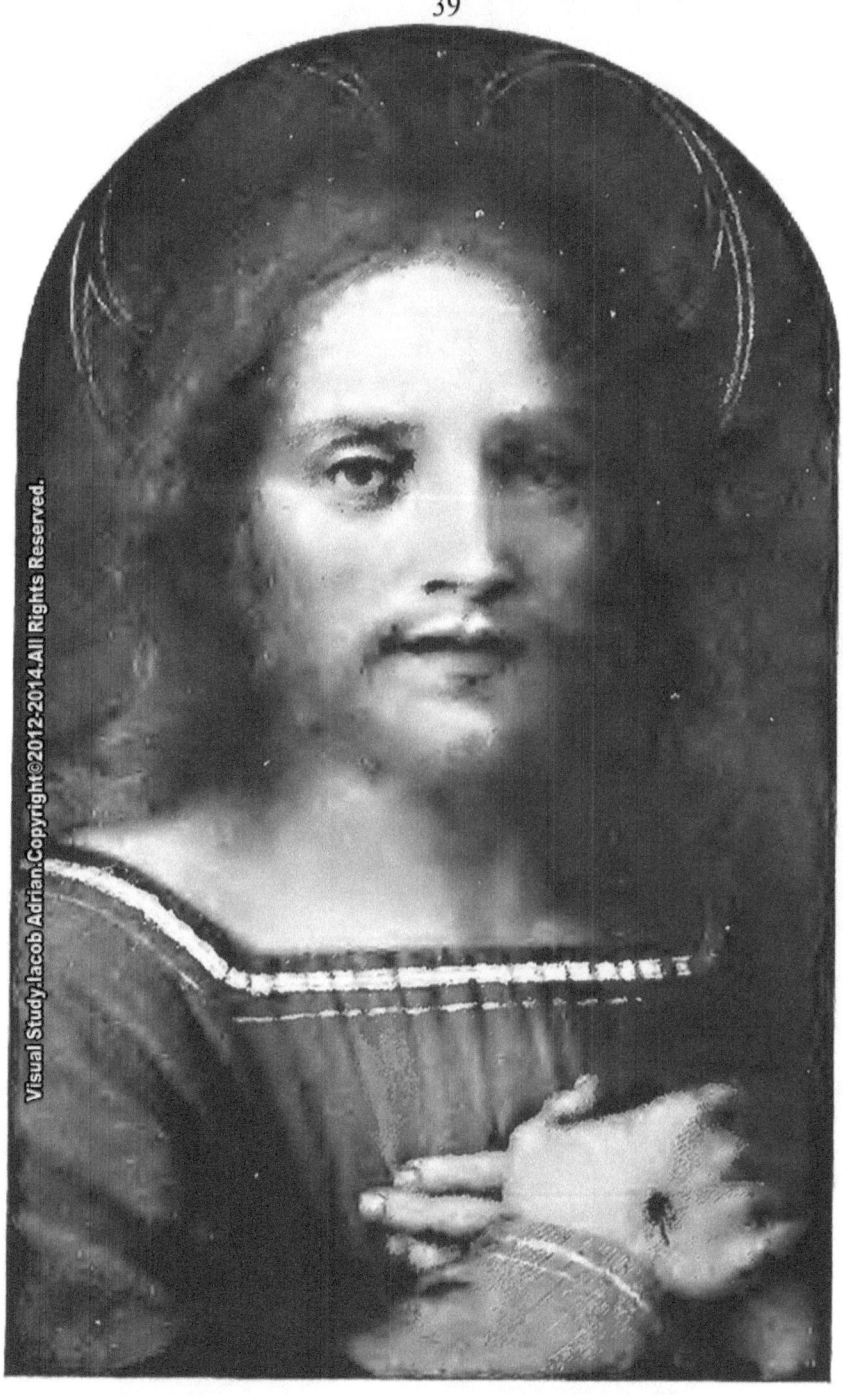

HEAD OF CHRIST (FRESCO) (SS. Annunziata, Florence)
LA TÊTE DU CHRIST (FRESQUE) (SS. Annunziata, Florence)
DER KOPF CHRISTI (FRESKE) (Florenz, SS. Annunziata) Frat. Alinari, Photo.

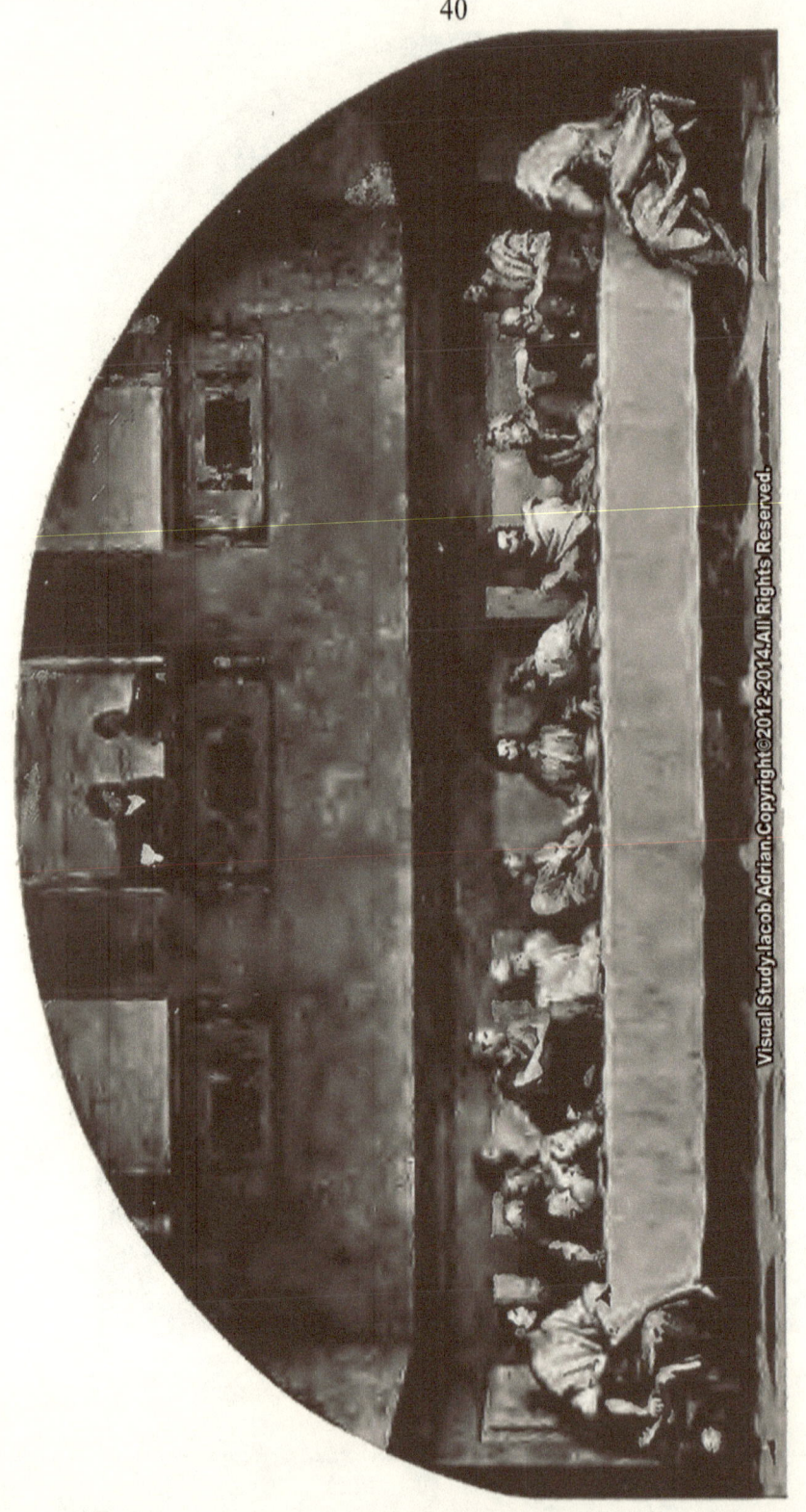

The Last Supper (Fresco) Das hl. Abendmahl (Freske) La Sainte Cène (Fresque)
(S. Salvi, Florence) (Florenz, S. Salvi) (S. Salvi, Florence)
D. Anderson, Photo.

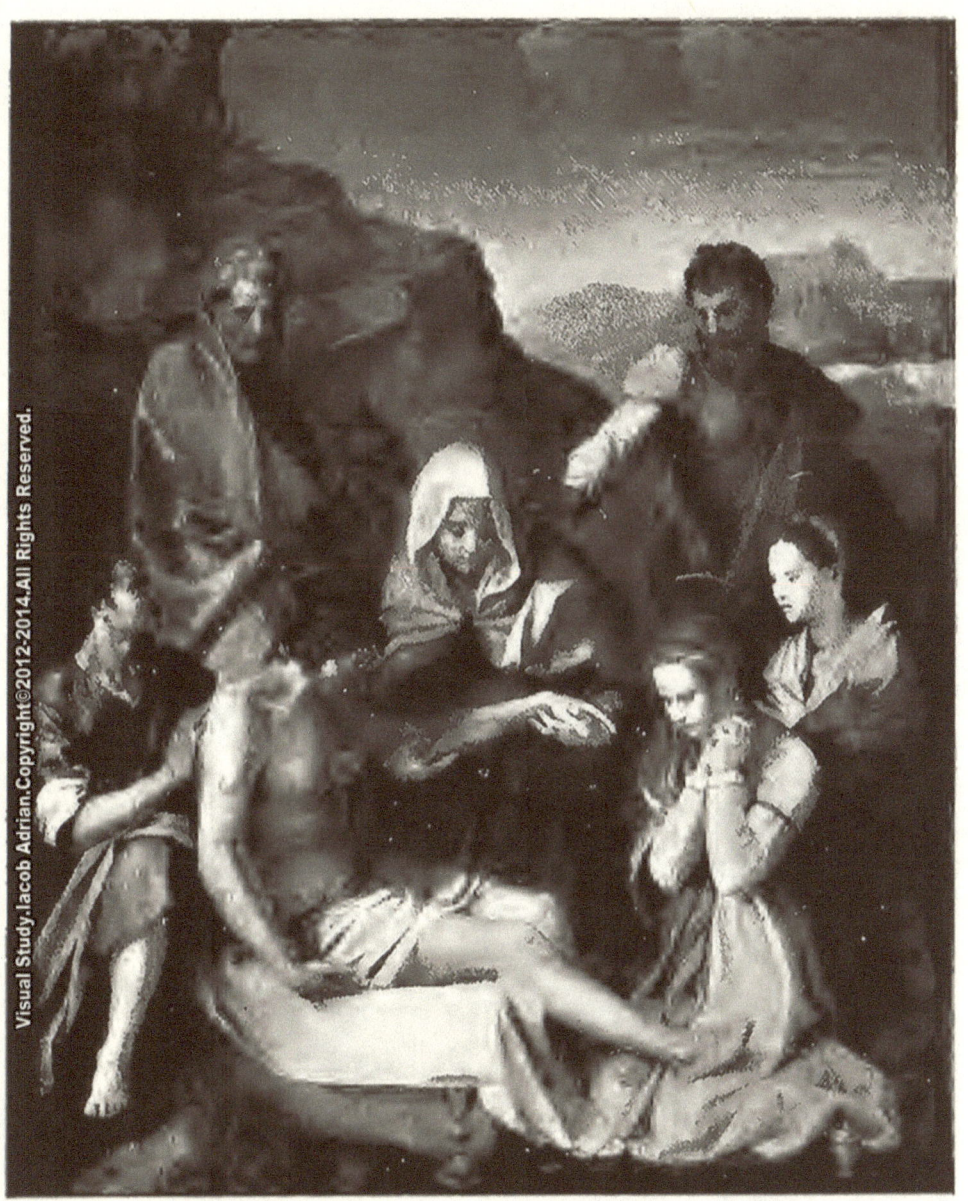

THE MOURNING FOR CHRIST
(*Pitti, Florence*)

LE CHRIST PLEURÉ
(*Galerie Pitti, Florence*)

BEWEINUNG CHRISTI
(*Florenz, Galerie Pitti*)
F. Hanfstaengl, Photo.

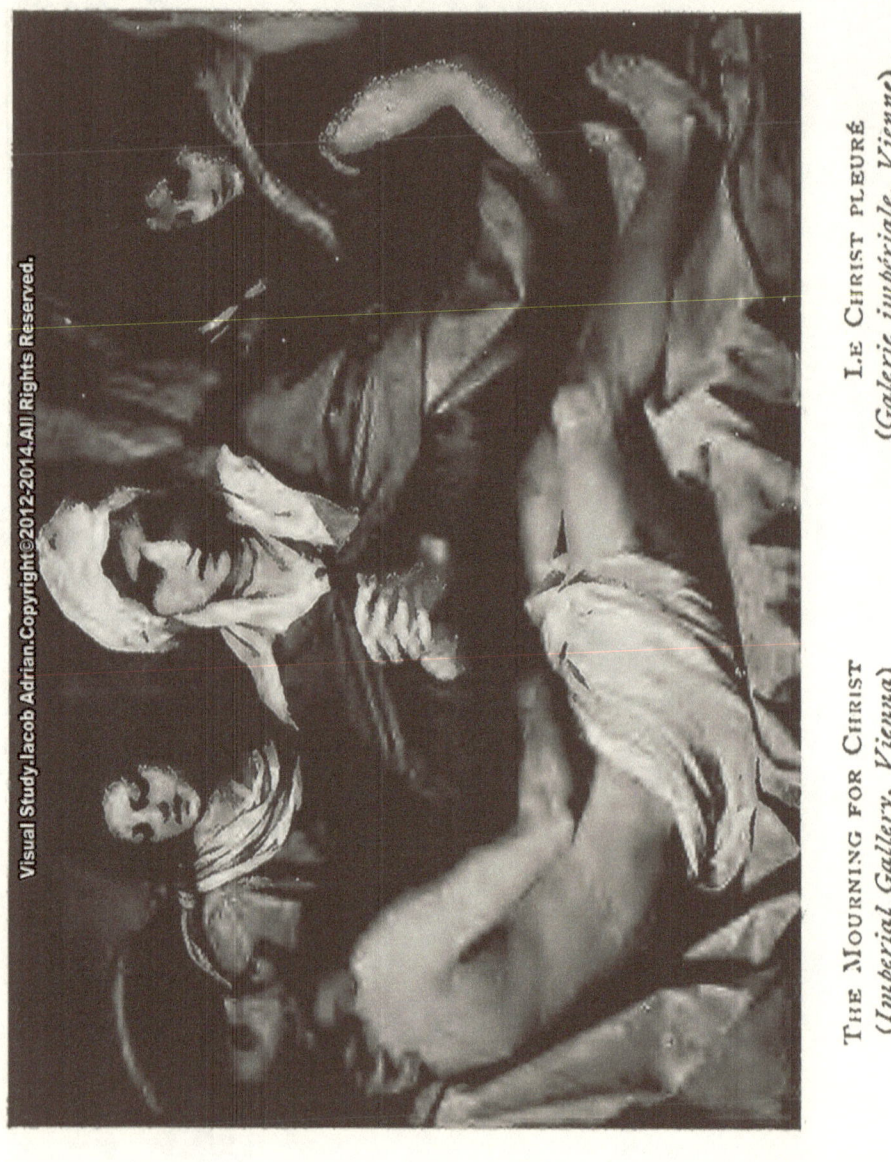

The Mourning for Christ
(Imperial Gallery, Vienna)

Le Christ pleuré
(Galerie impériale, Vienne)

Beweinung Christi
(Wien, Kaiserl. Galerie) F. Hanfstaengl, Photo.

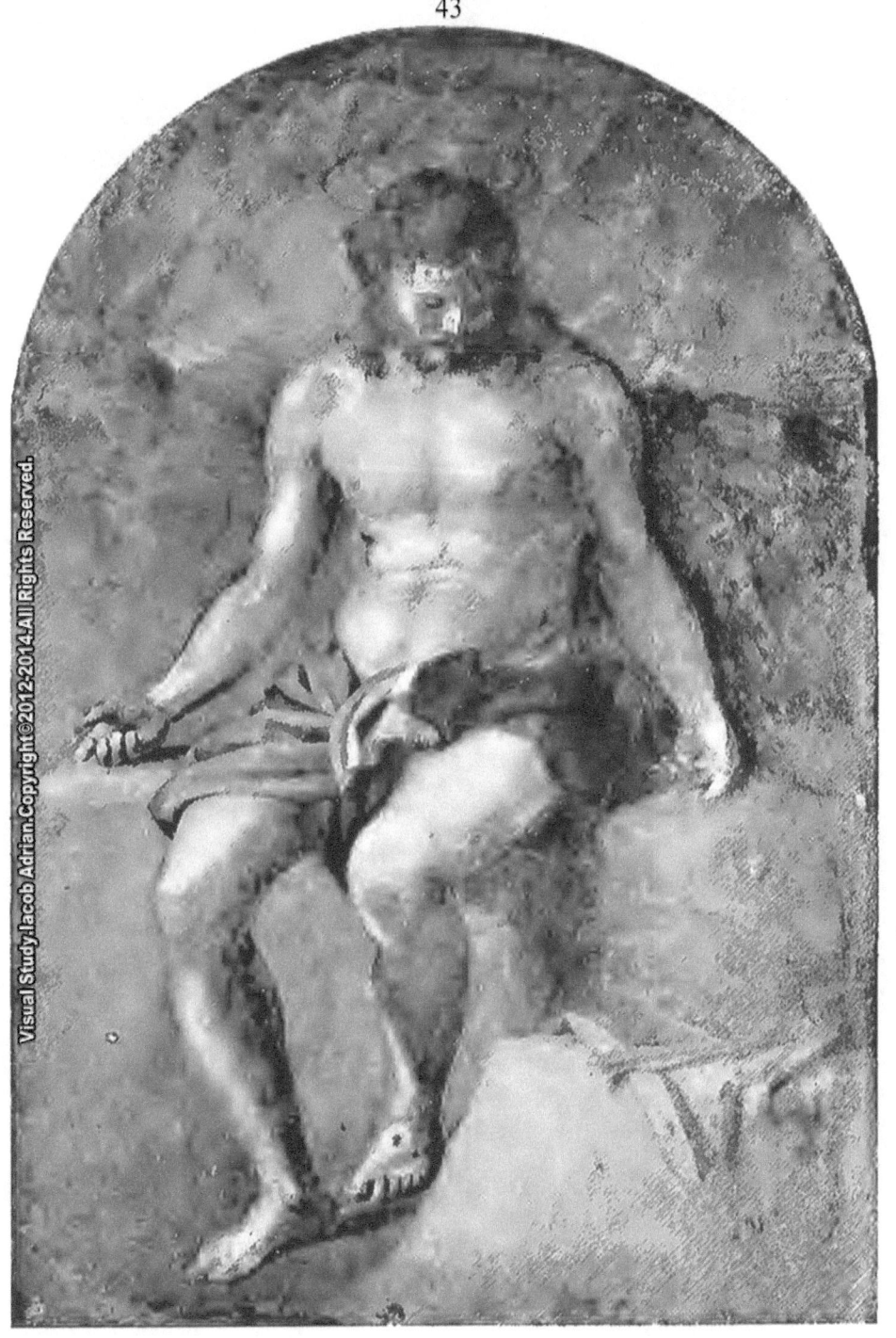

DEAD CHRIST (FRESCO) LE CHRIST MORT (FRESQUE)
(*Academy, Florence*) (*Académie, Florence*)
DER TOTE CHRISTUS (FRESKE)
(*Florenz, Akademie*) G. Brogi, Photo.

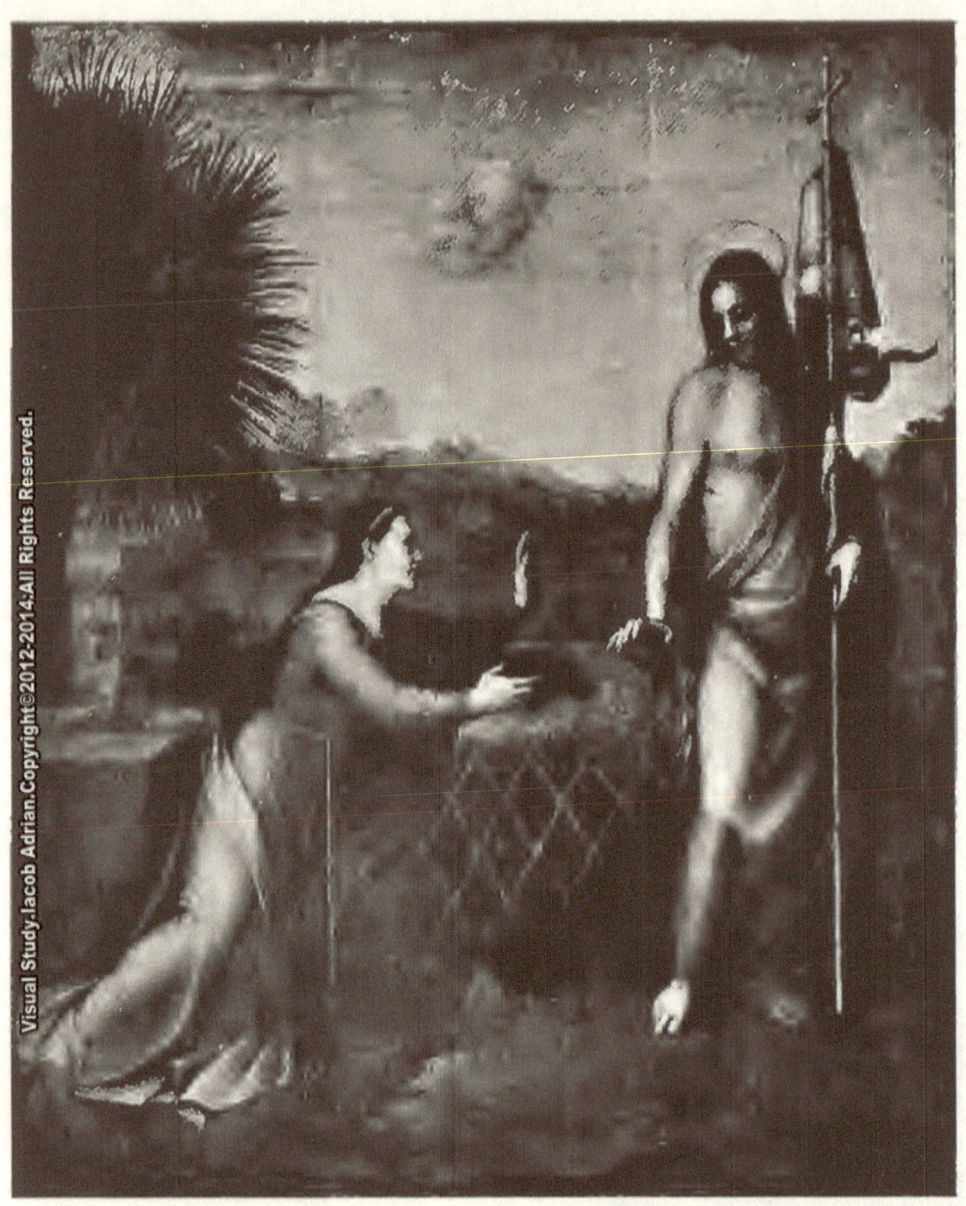

"Noli me Tangere"
(Uffizi, Florence)

"Noli me Tangere"
(Galerie des Offices, Florence)

"Noli me tangere"
(Florenz, Uffizien)
Frat. Alinari, Photo.

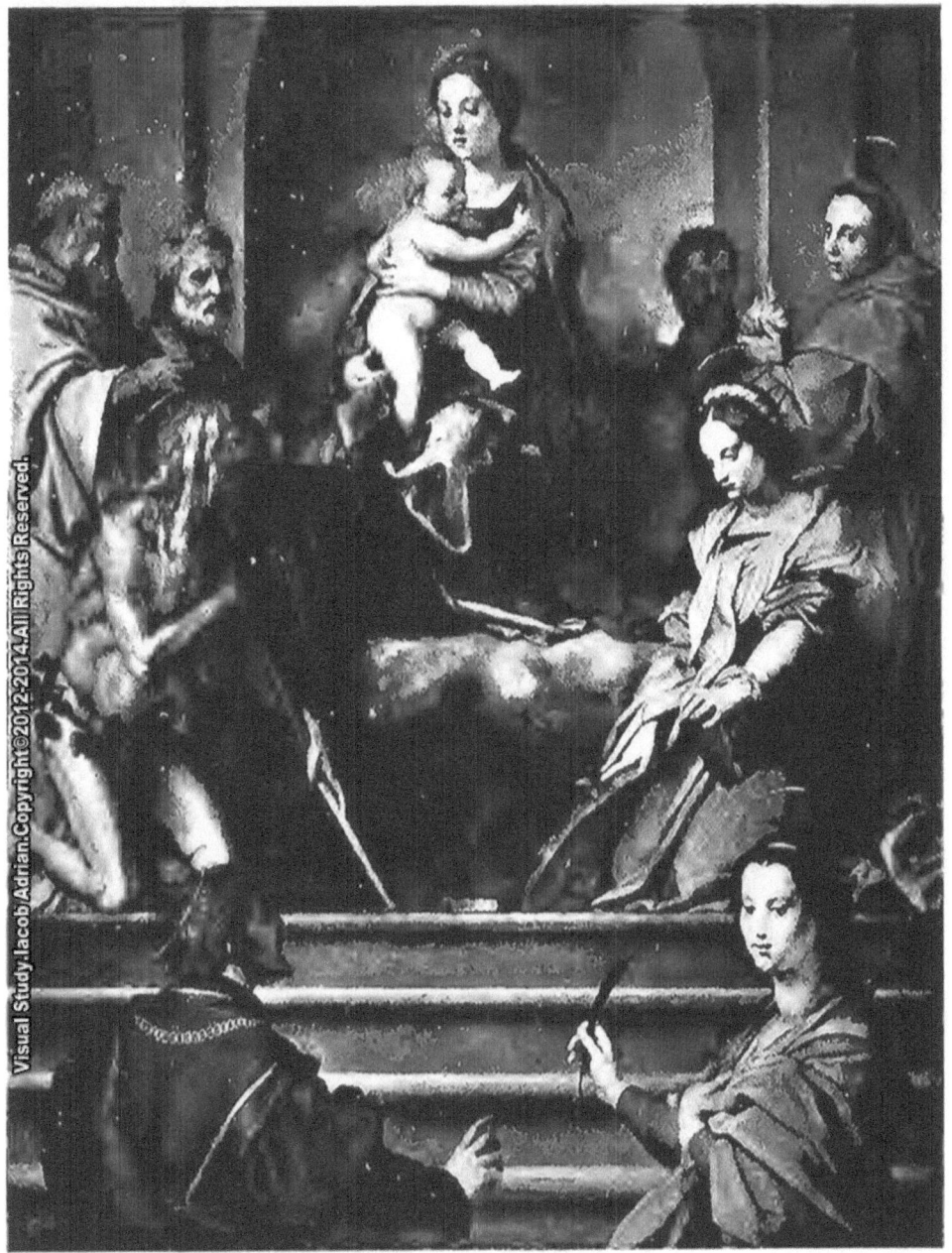

THE VIRGIN AND CHILD 　　　LA VIERGE ET L'ENFANT
　　WITH SAINTS 　　　　　　　AVEC DES SAINTS
(*Royal Gallery, Berlin*) 　　　　(*Musée royal, Berlin*)
　　MARIA MIT DEM KINDE UND HEILIGEN
　　　　　(*Berlin, Kgl. Galerie*)
　　　　F. *Hanfstaengl, Photo.*

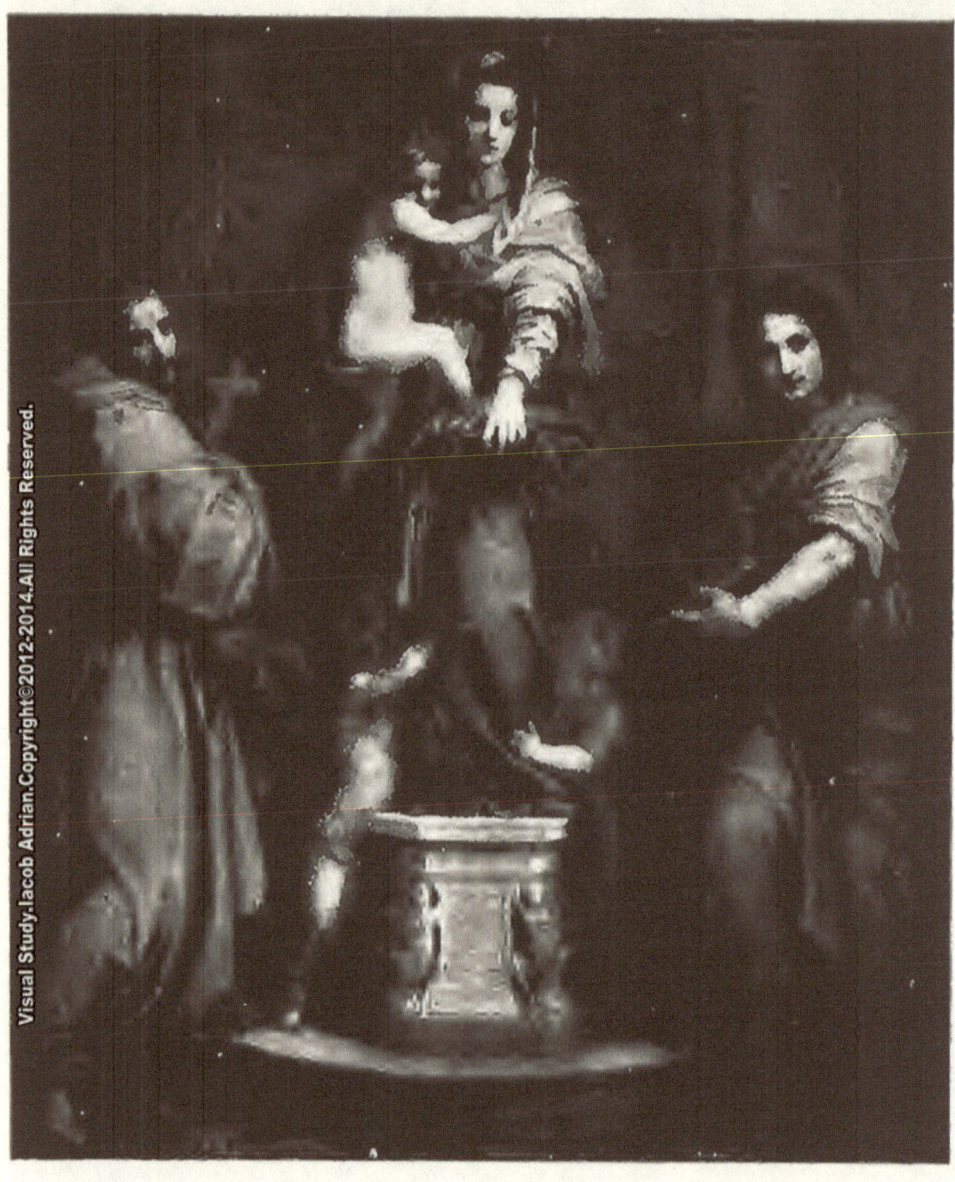

THE VIRGIN AND CHILD WITH SAINTS LA VIERGE ET L'ENFANT
("MADONNA DELL'ARPIE") AVEC DES SAINTS
(*Uffizi, Florence*) (*Galerie des Offices, Florence*)
MARIA MIT DEM KINDE UND HEILIGEN
(*Florenz, Uffizien*)
F. Hanfstaengl, Photo.

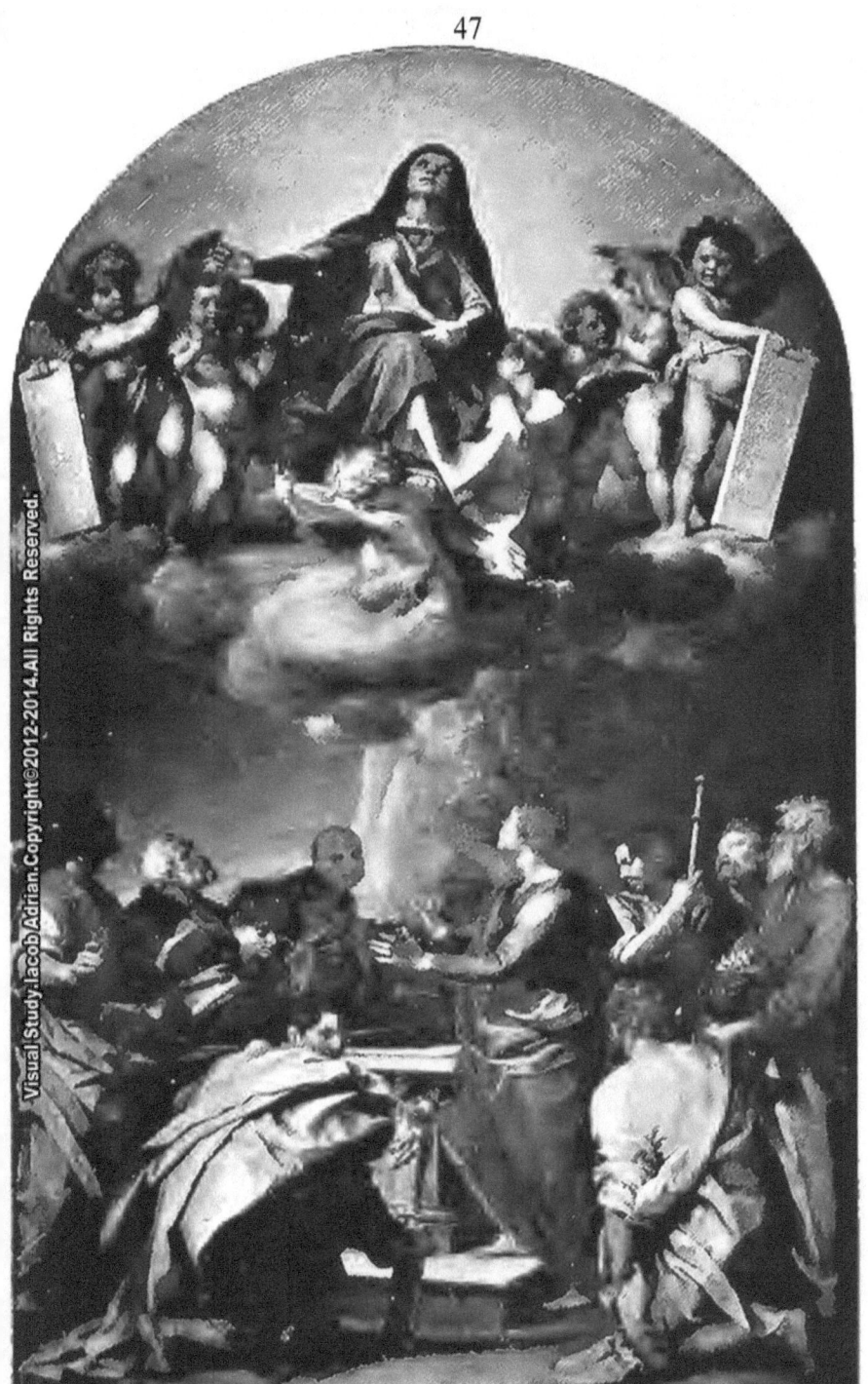

THE ASSUMPTION
(*Pitti, Florence*)

L'ASSOMPTION
(*Galerie Pitti, Florence*)

MARIÄ HIMMELFAHRT
(*Florenz, Galerie Pitti*)

D. Anderson, Photo.

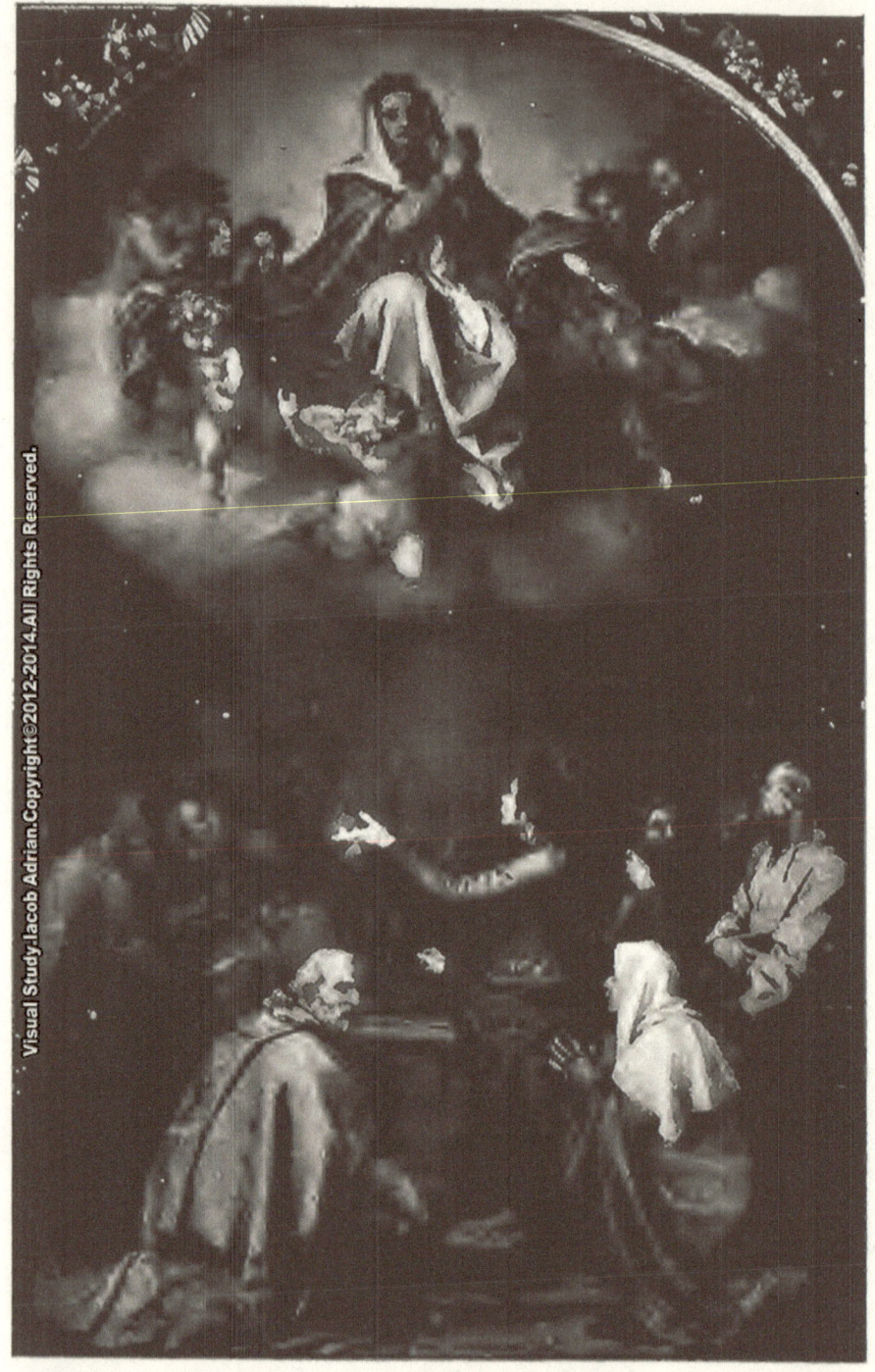

THE ASSUMPTION L'ASSOMPTION
(Pitti, Florence) (Galerie Pitti, Florence)
MARIÄ HIMMELFAHRT
(Florenz, Galerie Pitti) F. Hanfstaengl, Photo.

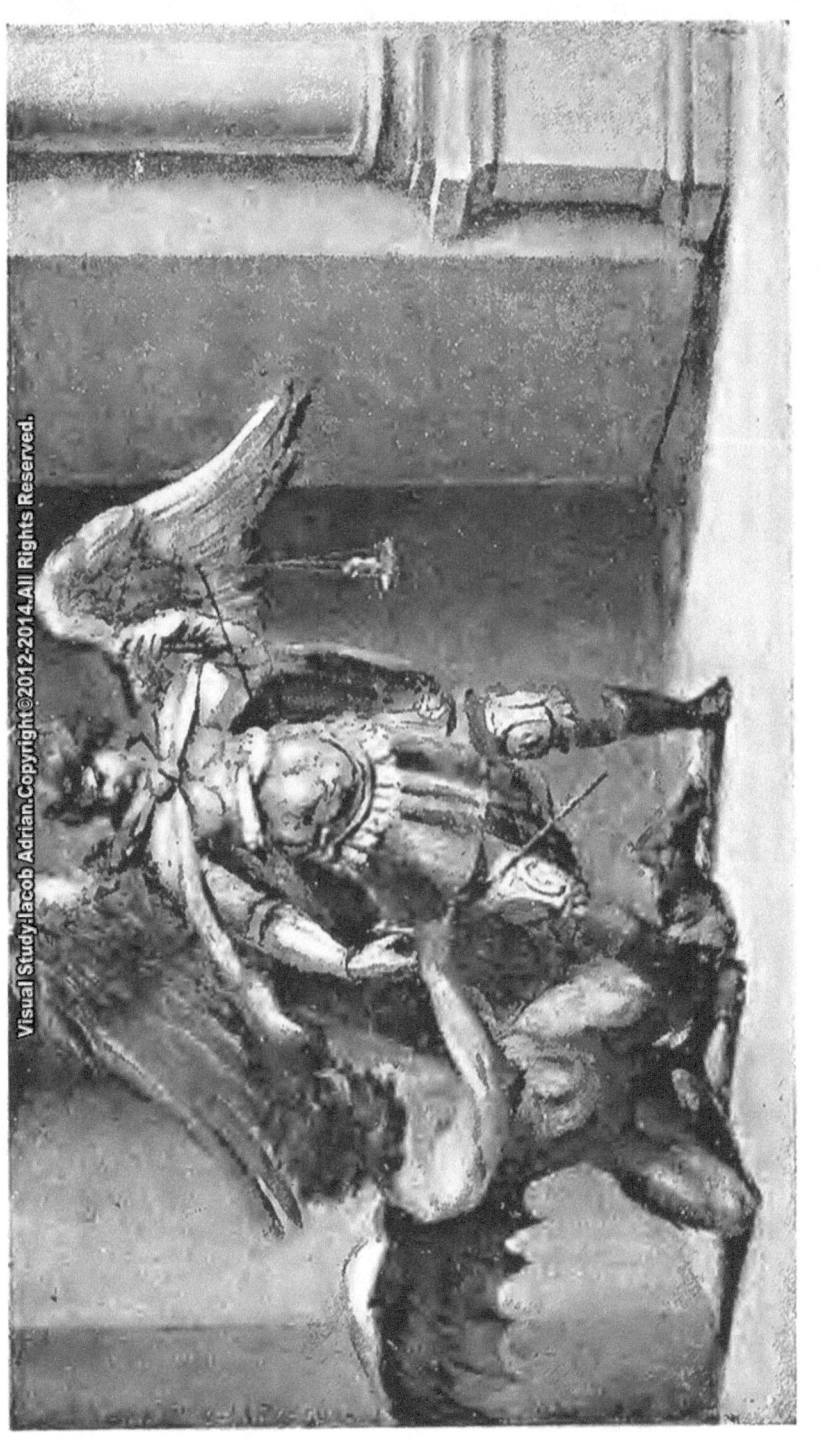

MICHAEL FIGHTING SATAN
(*Academy, Florence*)

[PREDELLA]

MICHEL COMBATTANT SATAN
(*Académie, Florence*)

MICHAEL MIT DEM SATAN KÄMPFEND
(*Florenz, Akademie*)

Frat. Alinari, Photo.

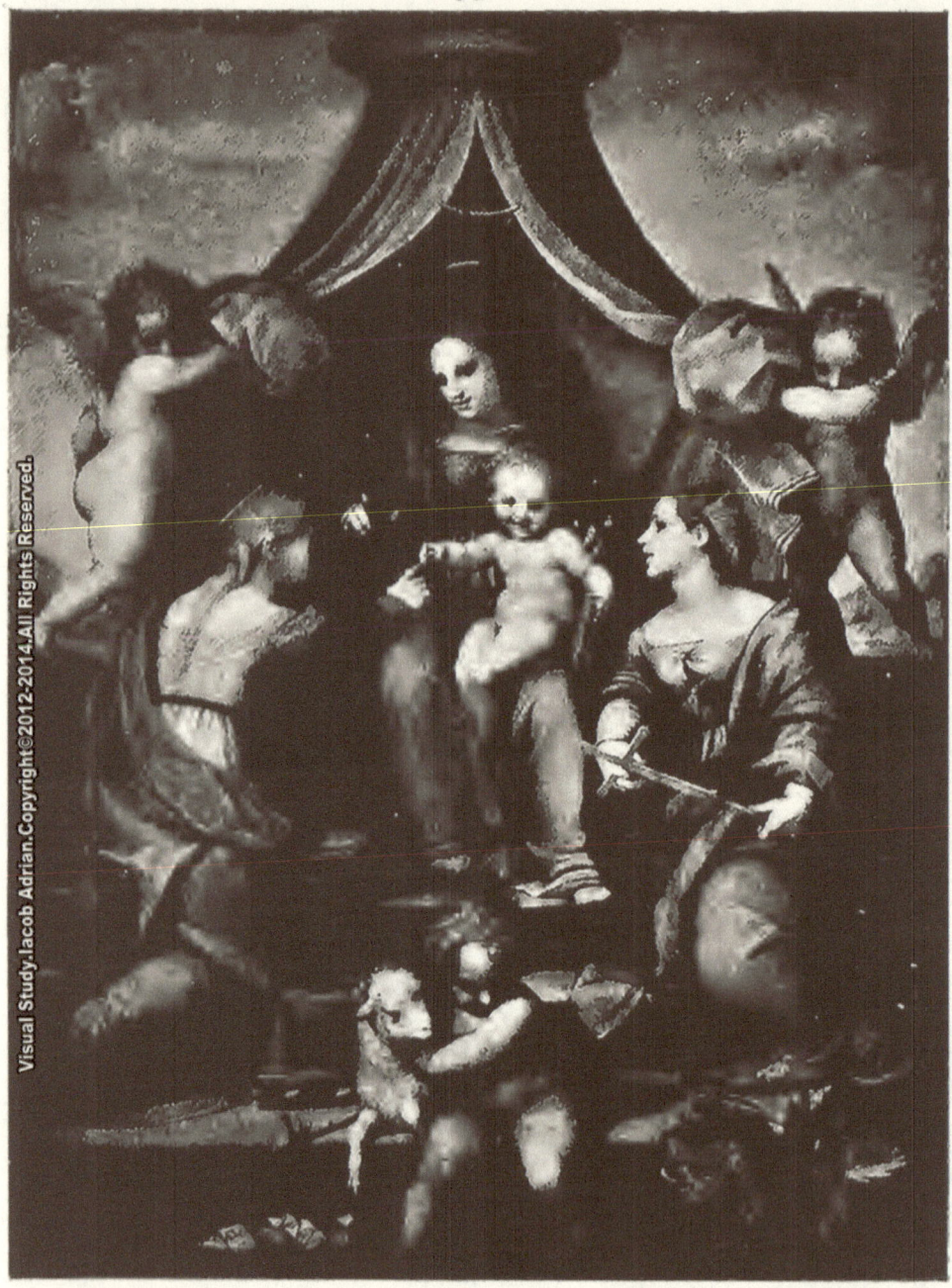

THE MARRIAGE OF
ST. CATHERINE
(Royal Gallery, Dresden)

LE MARIAGE DE
SAINTE CATHERINE
(Galerie royale, Dresde)

VERMÄHLUNG DER HL. KATHARINA
(Dresden, Kgl. Galerie)
V.·A. Bruckmann, Photo.

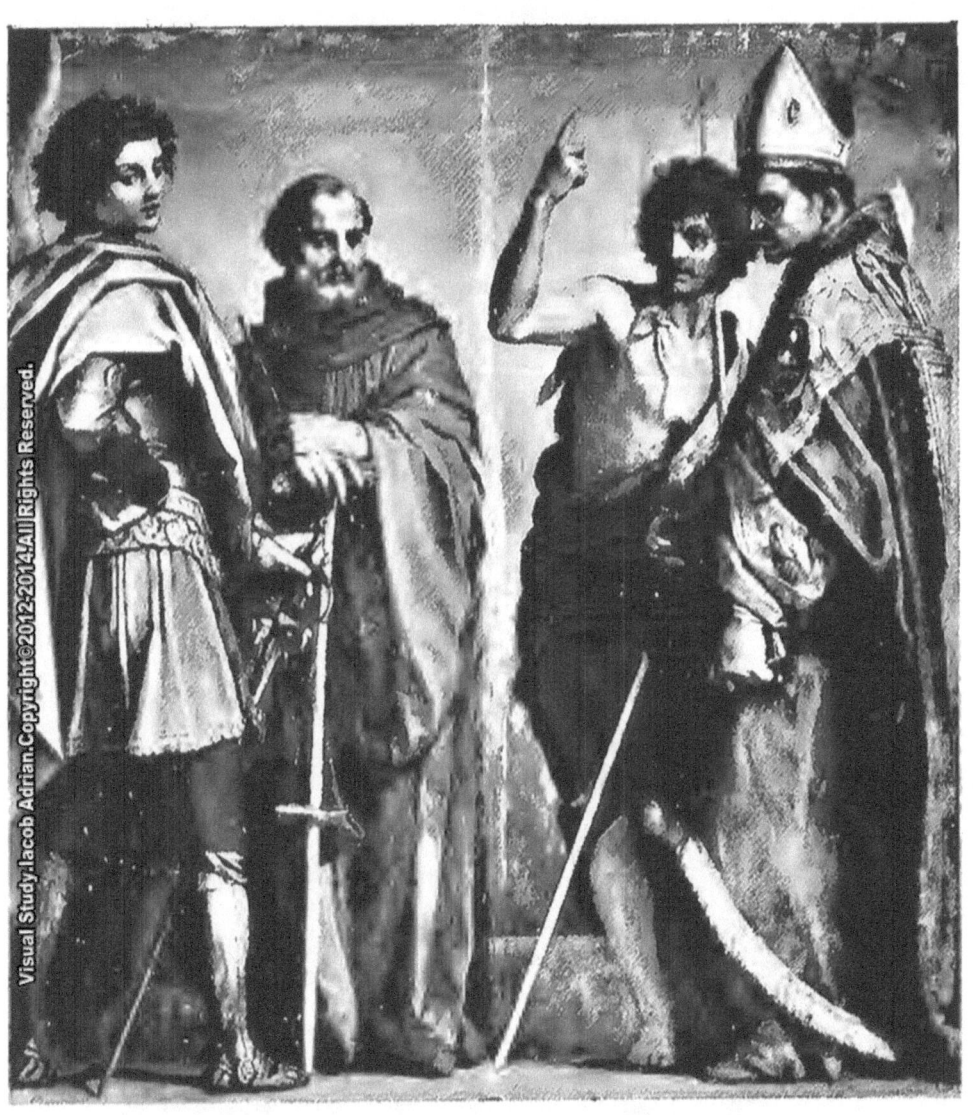

Four Saints
(Academy, Florence)

Quatre Saints
(Académie, Florence)

Vier Heilige
(Florenz, Akademie)
D. Anderson, Photo.

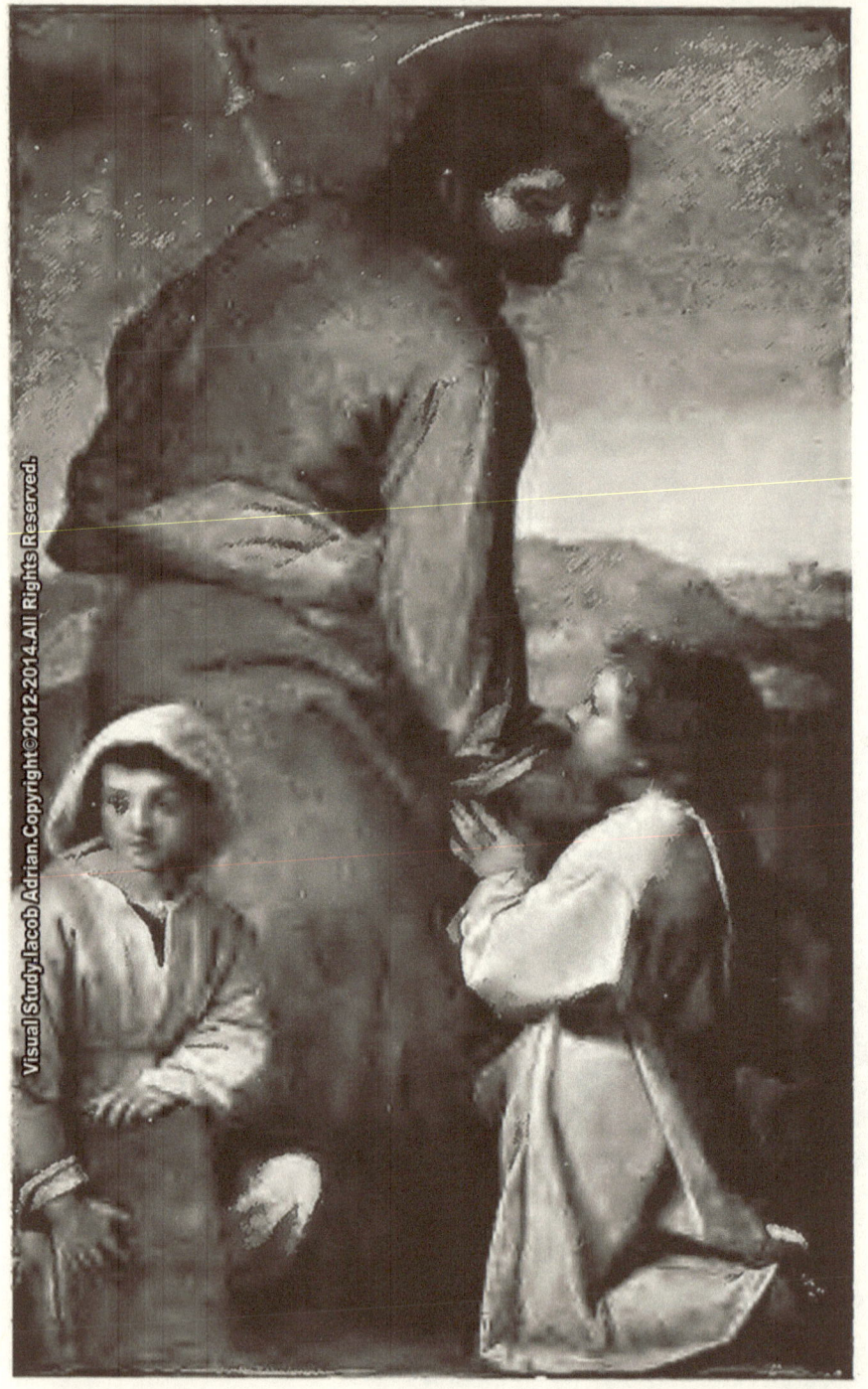

ST. JAMES
(Uffizi, Florence)

SAINT JACQUES
(Galerie des Offices, Florence)

ST. JAKOB
(Florenz, Uffizien)

D. Anderson, Photo.

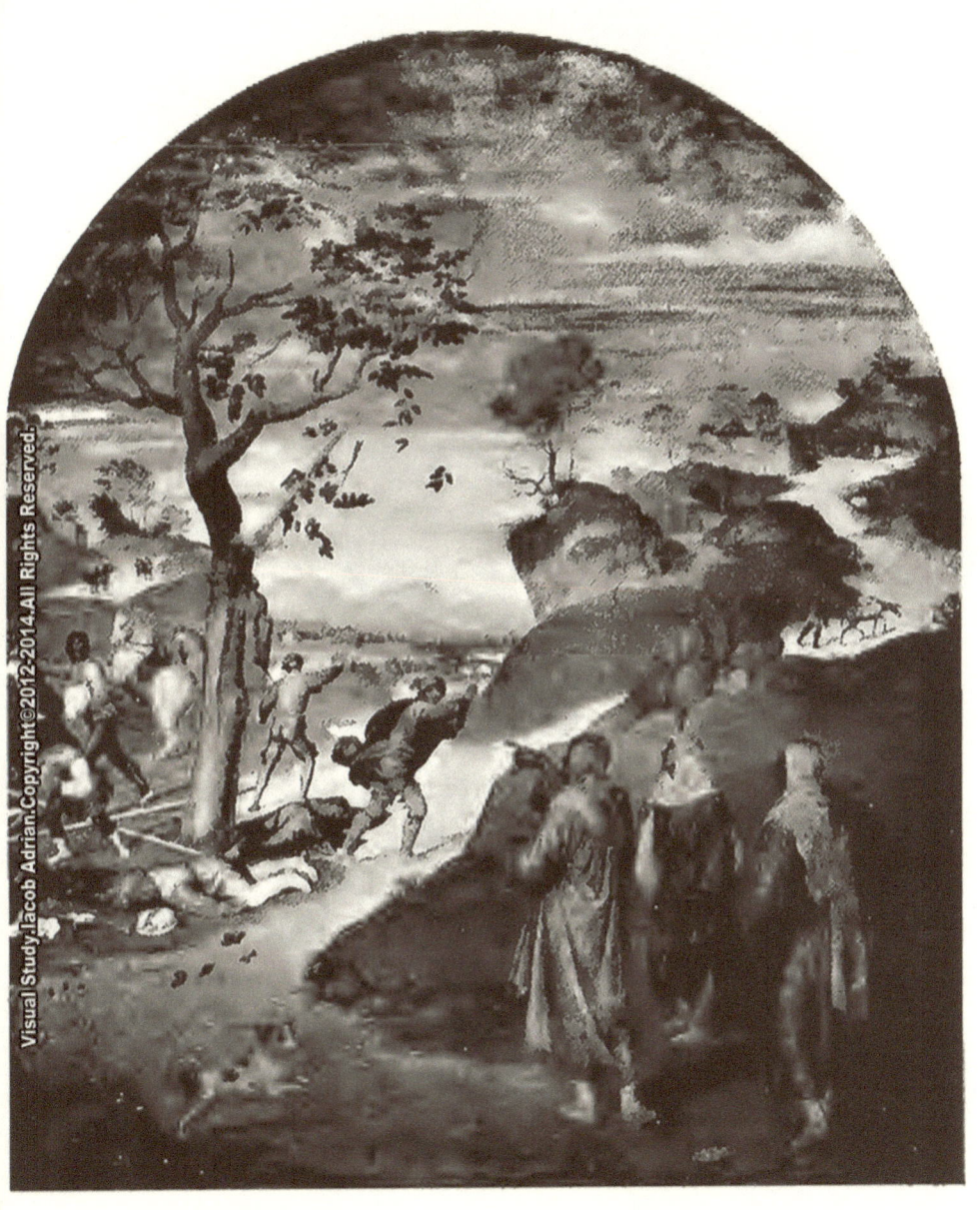

A MIRACLE OF
ST. PHILIP BENIZZI (FRESCO)
(*SS. Annunziata, Florence*)

UN MIRACLE DE
SAINT PHILIPPE BENIZZI (FRESQUE)
(*SS. Annunziata, Florence*)

EIN WUNDERWERK DES HL. PHILIPP BENIZZI (FRESKE)
(*Florenz, SS. Annunziata*)

D. Anderson, Photo.

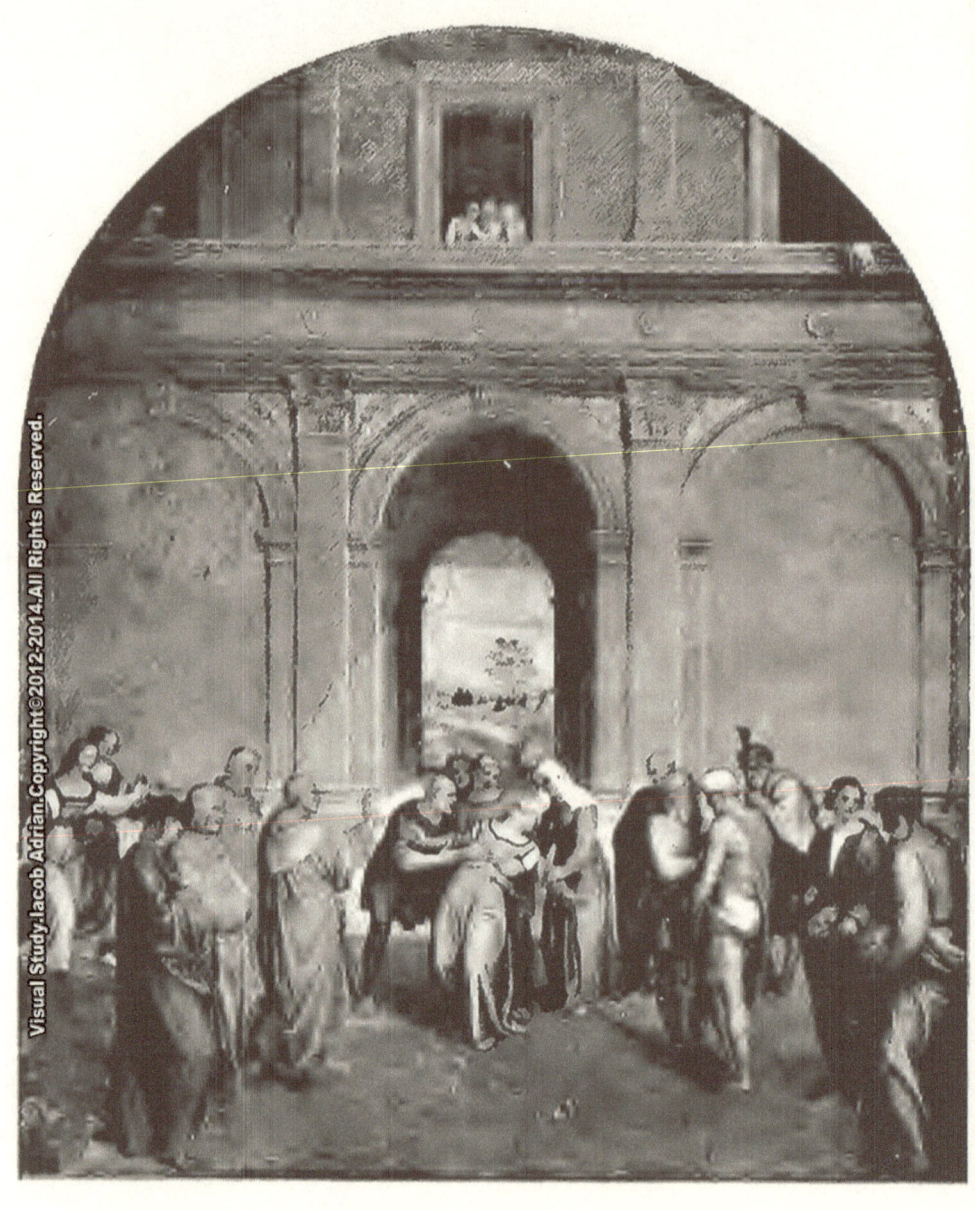

A MIRACLE OF
ST. PHILIP BENIZZI (FRESCO)
(SS. Annunziata, Florence)
UN MIRACLE DE
SAINT PHILIPPE BENIZZI (FRESQUE)
(SS. Annunziata, Florence)
EIN WUNDERWERK DES HL. PHILIPP BENIZZI (FRESKE)
(Florenz, SS. Annunziata)
D. Anderson, Photo

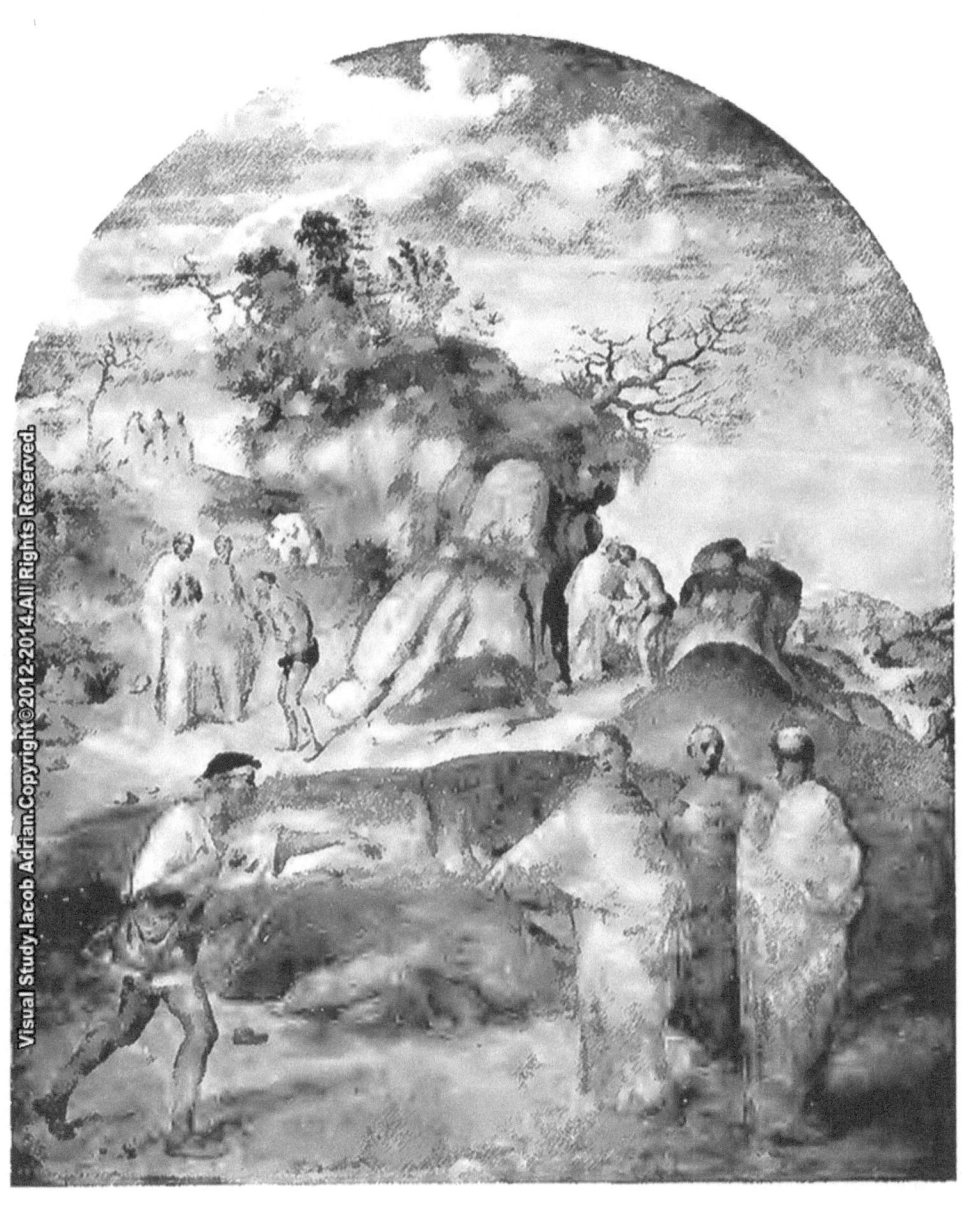

A MIRACLE OF
ST. PHILIP BENIZZI (FRESCO)
(SS. Anunziata, Florence)
UN MIRACLE DE
SAINT PHILIPPE BENIZZI (FRESQUE)
(SS. Annunziata, Florence)
EIN WUNDERWERK DES HL. PHILIPP BENIZZI (FRESKE)
(Florenz, SS. Annunziata)
D. Anderson, Photo.

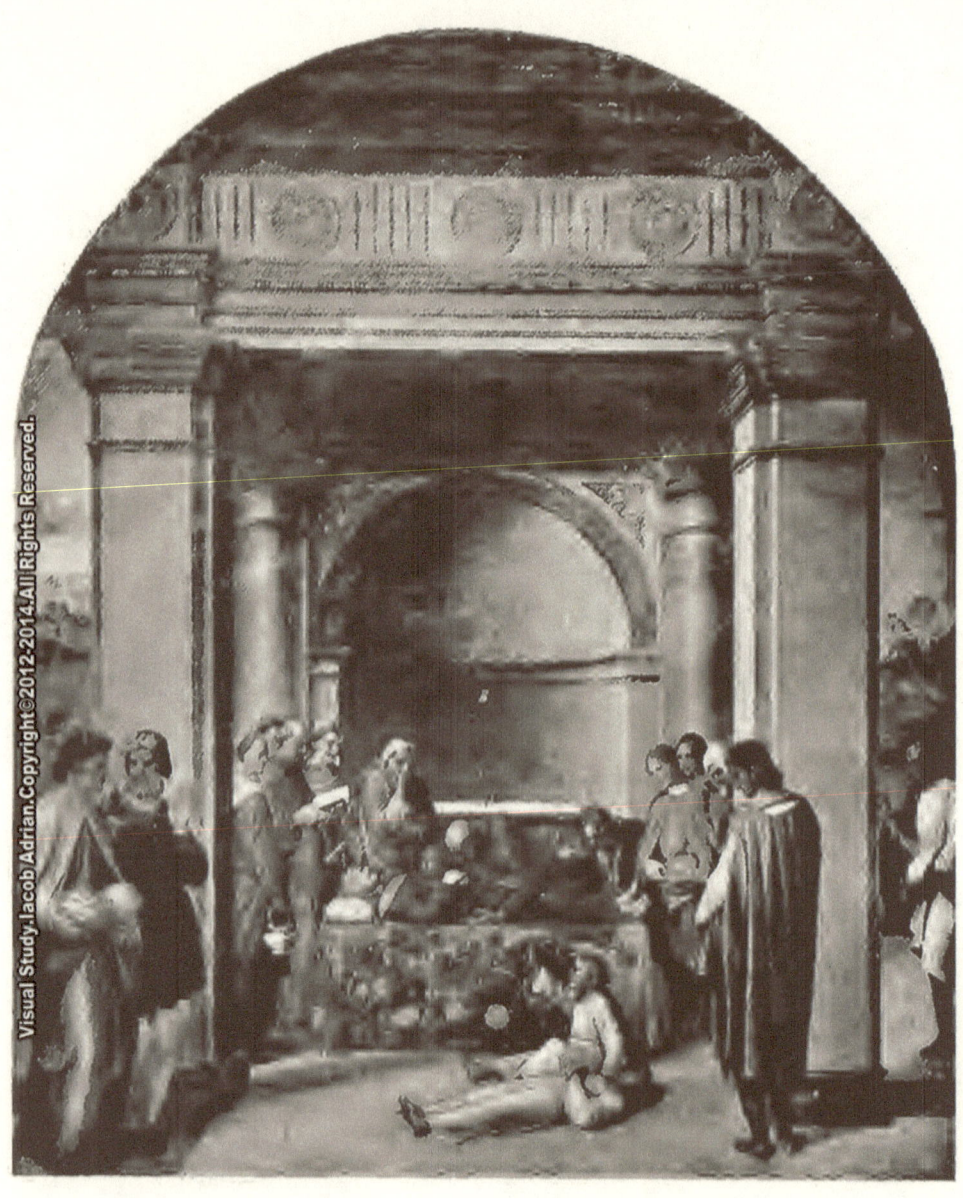

THE OBSEQUIES OF LES OBSÈQUES DE
ST. PHILIP BENIZZI (FRESCO) SAINT PHILIPPE BENIZZI (FRESQUE)
(SS. Annunziata, Florence) (SS. Annunziata, Florence)
DIE TOTENFEIER DES HL. PHILIPP BENIZZI (FRESKE)
(Florenz, SS. Annunziata)
D. Anderson, Photo.

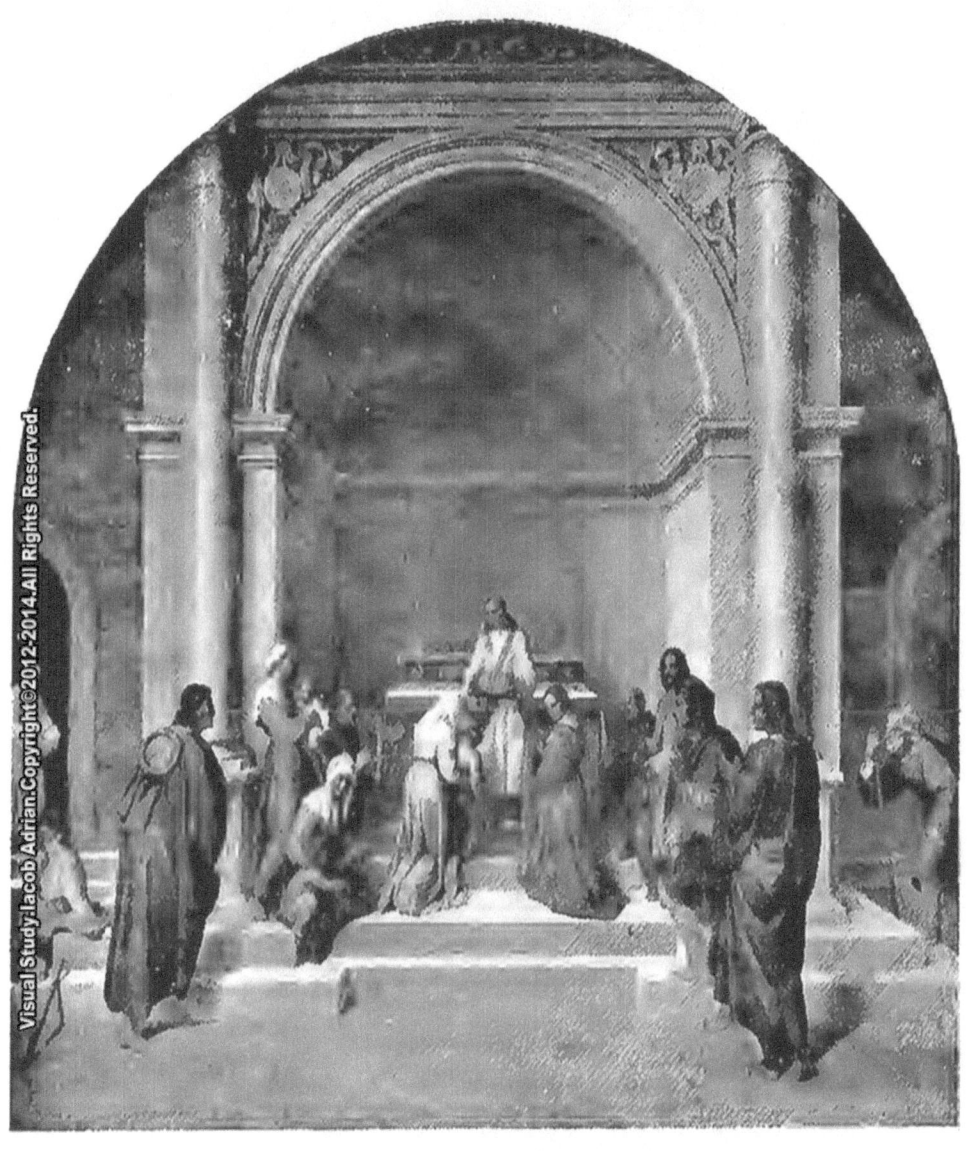

KISSING ST. PHILIP BENIZZI'S GARMENTS (FRESCO)
(*SS. Annunziata, Florence*)

LE BAISEMENT DES VÊTEMENTS DE SAINT PHILIPPE BENIZZI (FRESQUE)
(*SS. Annunziata, Florence*)

DAS KÜSSEN DER GEWÄNDER DES HL. PHILIPP BENIZZI (FRESKE)
(*Florenz, SS. Annunziata*)

D. Anderson, Photo.

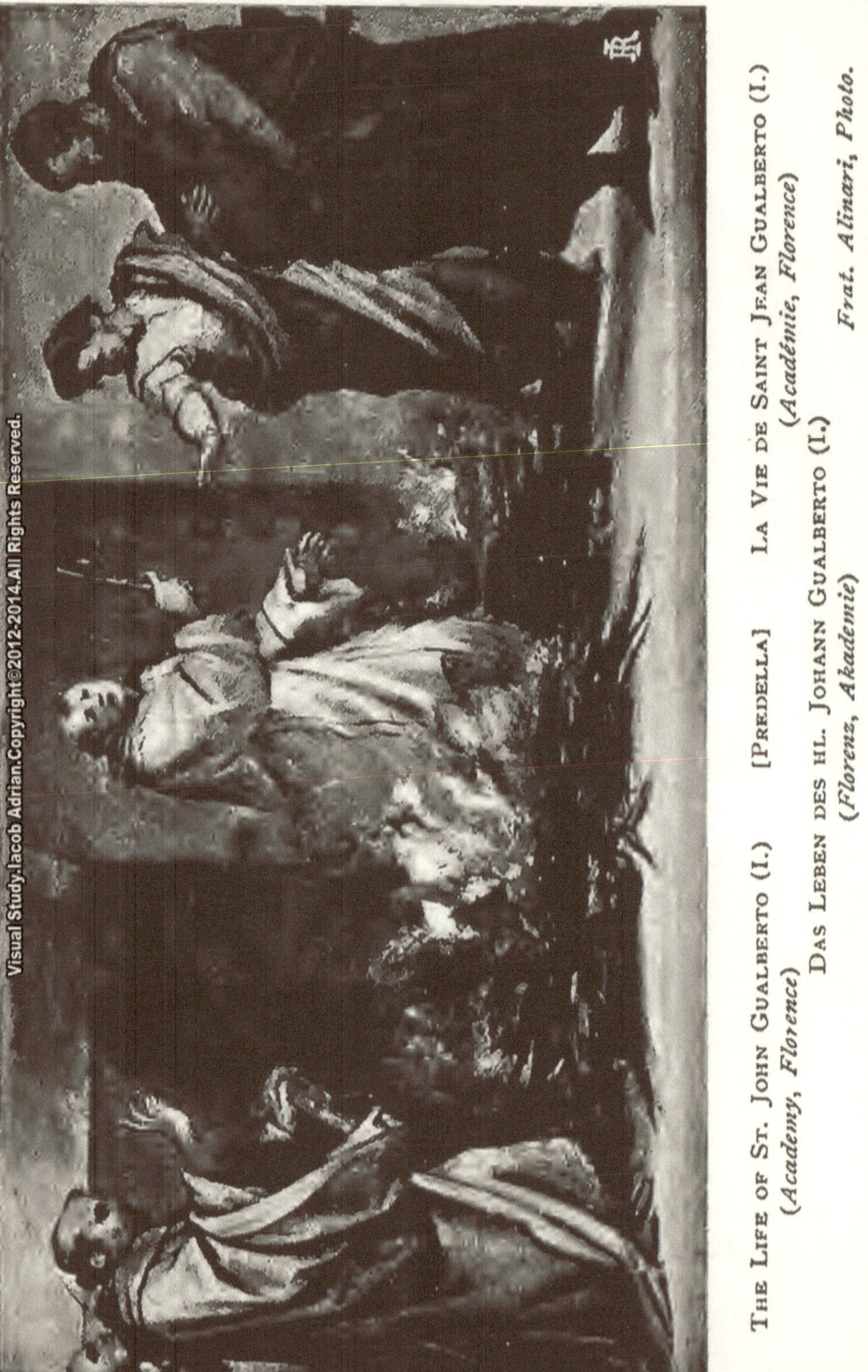

The Life of St. John Gualberto (I.) [Predella] La Vie de Saint Jean Gualberto (I.)
(*Academy, Florence*) (*Académie, Florence*)
Das Leben des hl. Johann Gualberto (I.)
(*Florenz, Akademie*)

Frat. Alinari, Photo.

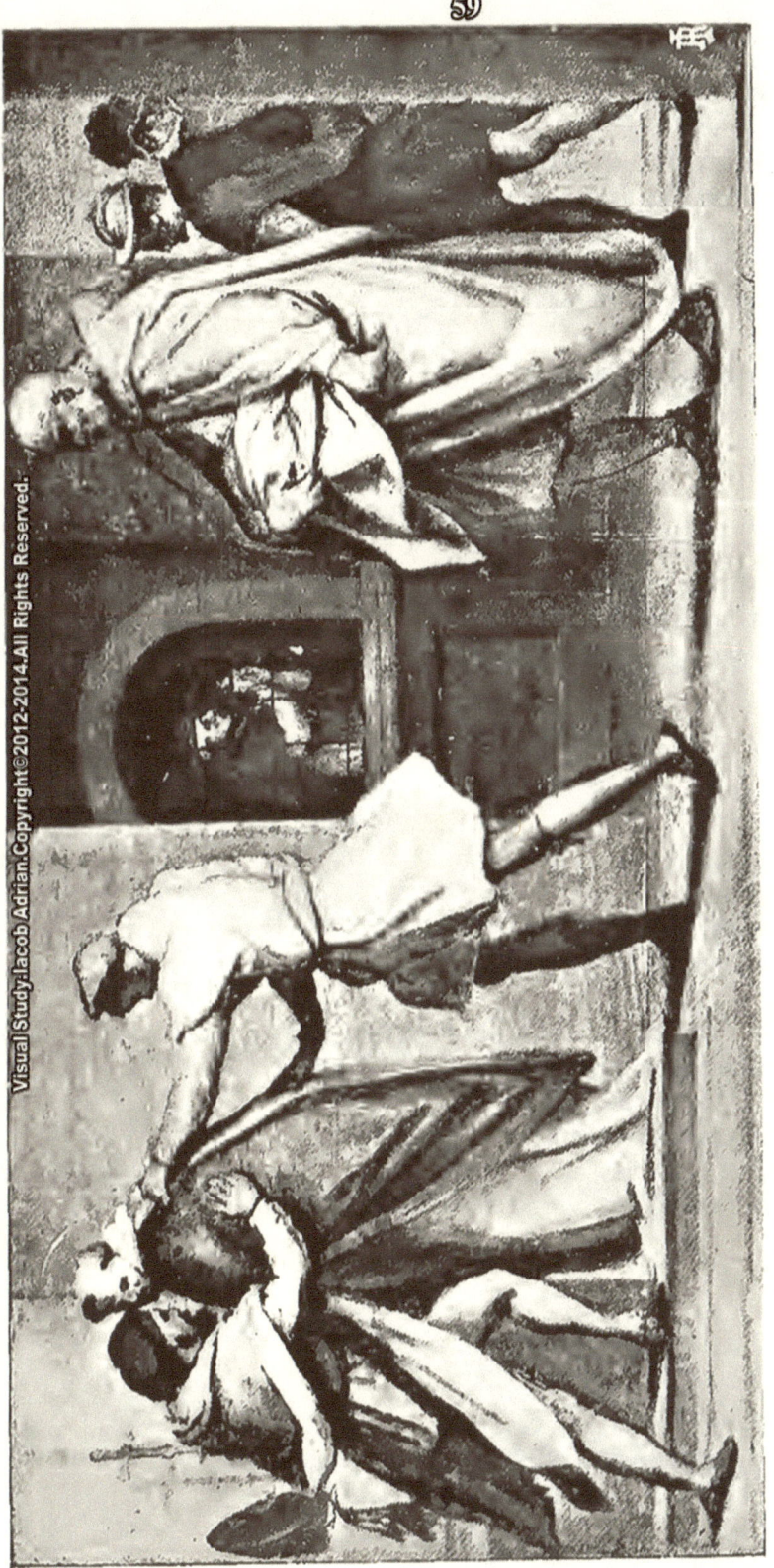

The Life of St. John Gualberto (II.) [Predella] La Vie de Saint Jean Gualberto (II.)
(Academy, Florence) (Académie, Florence)
Das Leben des hl. Johann Gualberto (II.)
(Florenz, Akademie)

Frat. Alinari, Photo.

Bibliographic sources :

The masterpieces of Andrea del Sarto; sixty reproductions of photographs from the original paintings, affording examples of the different characteristics of the artist's work (1908)

Author: Andrea del Sarto, 1486-1531

Publisher: London, Gowans

This documentary study use,
combined in various proportions,
elements from the following categories,
forms and subsets :
- fair use
- documentary
- documentary photography
- feature
- journalism
- arts journalism
- visual journalism
- photojournalism
- celebrity photography
in order to :
- employ material as the object of cultural critique ,
- quote to illustrate an argument or point ,
- use material in historical sequence,
providing independent opinion,
using photos, press articles, advertisements,
opinions of fans etc. ...

Copyright©2012-2014 Iacob Adrian
All Rights Reserved.

www.ingramcontent.com/pod-product-compliance
Lightning Source LLC
Chambersburg PA
CBHW021021180526
45163CB00005B/2063